PHOTOSECRETS
SAN FRANCISCO

WHERE TO TAKE PICTURES

BY
ANDREW HUDSON

*"A good photograph
is knowing where to stand."*
— Ansel Adams

A GREAT TRAVEL photograph, like a great news photograph, requires you to be in the right place at the right time to capture that special moment. Professional photographers have a short-hand phrase for this: "F8 and be there."

There are countless books that can help you with photographic technique, the "F8" portion of that equation. But until now, there's been little help for the other, more critical portion of that equation, the "be there" part.

To find the right spot, you had to expend lots of time and shoe leather to research the area, walk around, track down every potential viewpoint, see what works, and essentially re-invent the wheel.

In my career as a professional travel photographer, well over half my time on location is spent seeking out the good angles. Andrew Hudson's PhotoSecrets does all that legwork for you, so you can spend your time photographing instead of wandering about. It's like having a professional location scout in your camera bag. I wish I had one of these books for every city I photograph on assignment.

PhotoSecrets can help you capture the most beautiful sights with a minimum of hassle and a maximum of enjoyment. So grab your camera, find your favorite PhotoSecrets spots, and "be there!"

Bob Krist has photographed assignments for *National Geographic*, *National Geographic Traveler*, *Travel/Holiday*, *Smithsonian*, and *Islands*. He won "Travel photographer of the Year" from the Society of American Travel Writers in 1994, 2007, and 2008 and today shoots video as a Sony Artisan Of Imagery.

For *National Geographic*, Bob has led round-the-world tours and a traveling lecture series. His book *In Tuscany* with Frances Mayes spent a month on *The New York Times'* bestseller list and his how-to book *Spirit of Place* was hailed by *American Photographer* magazine as "the best book about travel photography."

After training at the American Conservatory Theater, Bob was a theater actor in Europe and a newspaper photographer in his native New Jersey. The parents of three sons, Bob and his wife Peggy live in New Hope, Pennsylvania.

☕ Contents

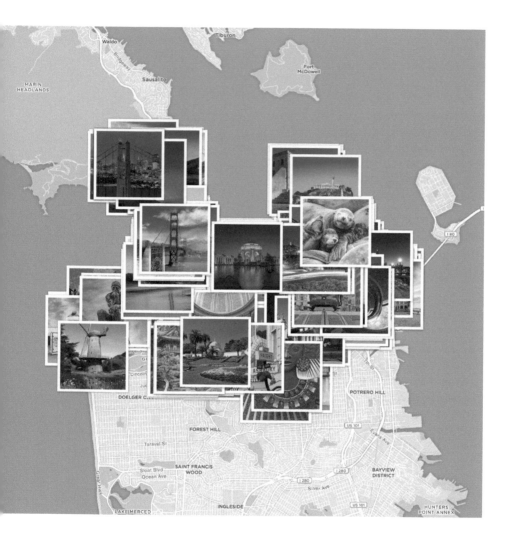

📍 Golden Gate Bridge

The **Golden Gate Bridge** is the most photographed bridge in the world and the icon of San Francisco. There are at least 20 viewpoints, covering all four corners.

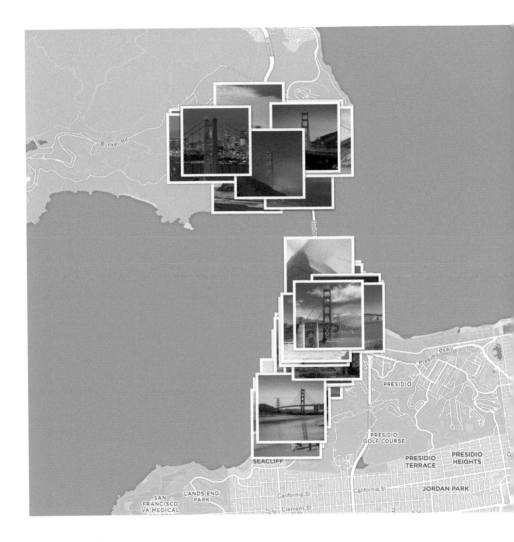

📍 Cable Cars

The **cable cars** climb the hills between downtown and Fisherman's Wharf, providing foregrounds to a variety of shots.

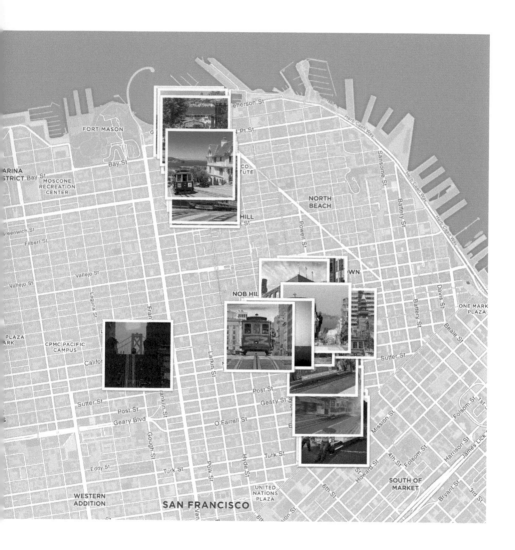

📍 Fisherman's Wharf

Fisherman's Wharf is a tourist attraction on the northern waterfront, famous for its Dungeness crabs, sourdough bread, and barking sea lions.

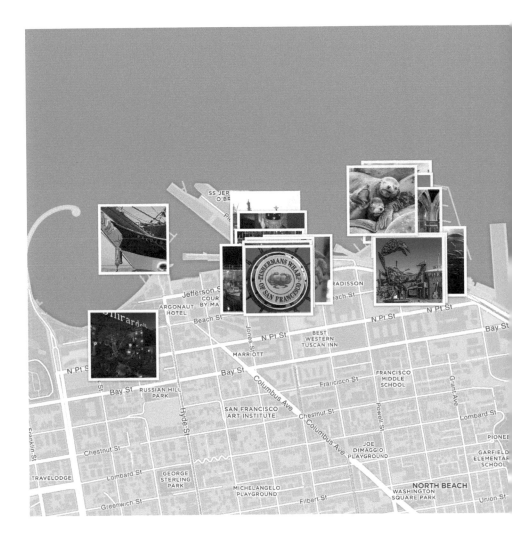

♀ Alcatraz

Alcatraz was the nation's most secure federal prison from 1934 to 1963. Located in cold and dangerous waters 1.25 miles (2 km) north of Fisherman's Wharf, no one is known to have escaped, so don't lose your ferry ticket.

📍 Golden Gate Park

Golden Gate Park stretches across most of the west half of San Francisco, and is 20% larger than New York's Central Park. Your camera will enjoy the Conservatory of Flowers, the Japanese Tea Garden, Stow Lake, and the world's largest windmill.

📍 Downtown San Francisco

Downtown is the main business district, including the Civic Center, Union Square, the Financial District and the Embarcadero.

📍 Elsewhere

Elsewhere in San Francisco are the original mission from 1776, "the crookedest street in the world" (Lombard Street), the Palace of Fine Arts, Coit Tower, and a giant camera.

ℹ Introduction

San Francisco beckons your camera with sweeping vistas and unique, indelible sights. From the majestic Golden Gate bridge and a soaring downtown skyline to romantic cable cars and quirky Lombard Street's hairpin turns, the region is home to an awesome array of spectacular and photo-worthy sights.

Covering about 47 square miles (121 kms) on the tip of a peninsula, the City and County of San Francisco — the area's official name — ranges between the Pacific Ocean and the largest Pacific estuary in the Americas. San Francisco was founded in 1776, when colonists from Spain established the Presidio and Mission of St. Francis of Assisi, known as San Francisco de Asis in Spanish. The California Gold Rush of 1849 brought rapid growth, making San Francisco the West Coast's largest city through to 1900, when around 25% of California's population resided in the city proper. Following the 1906 earthquake and fire, which destroyed three quarters of the city, San Francisco was quickly rebuilt and is now the cultural, commercial, and financial center of Northern California.

As the song says, you may leave your heart in San Francisco, but never fear: you will take great photos with you to remember the spectacular City by the Bay.

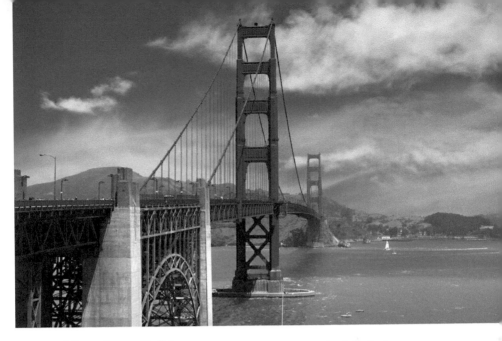

The **Golden Gate Bridge** is the must-photograph sight in San Francisco, leaping across the Golden Gate strait from the northwestern tip of the city to the Marin headlands in the north.

Proposed in 1917, the Art Deco structure opened in 1937 as the world's longest suspension bridge. The color is called *international orange* and chosen to complement the natural surroundings and enhance the bridge's visibility in fog.

The best place to start your exploration is the Golden Gate Bridge Welcome Center, which has gifts, books, and helpful staff. Around the plaza are exhibits, restrooms, transit stops and a restaurant.

From here, you can walk to the Coastal Trail and take the photo above, then head to the bridge or explore views along Battery East Trail.

✉ **Addr:**	Golden Gate Bridge, San Francisco CA 94129	♀ **Where:**	37.808017 -122.475365
◑ **When:**	Morning	◉ **Look:**	North-northwest
W **Wik:**	Golden_gate_bridge		

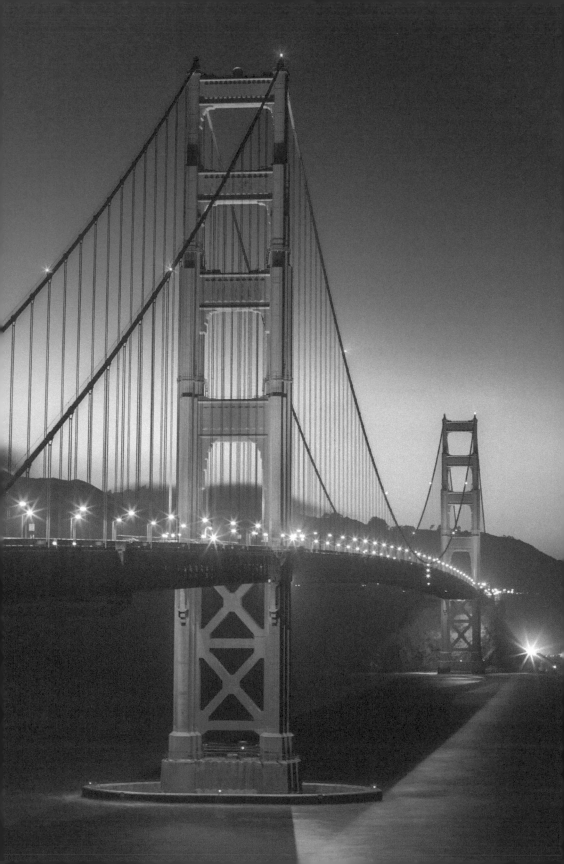

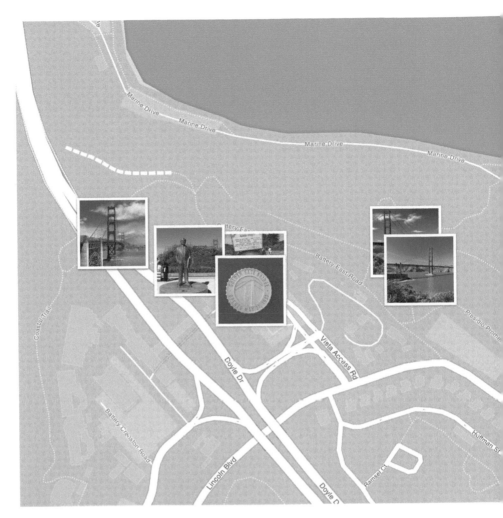

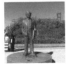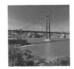
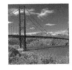

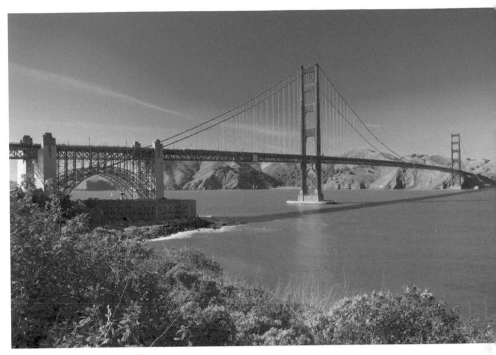

Battery East Trail offers several views. From the Welcome Center, walk east along the trail about 1,400 feet (420 m) to two viewpoints. Beyond is a scenic stairway down to Fort Point.

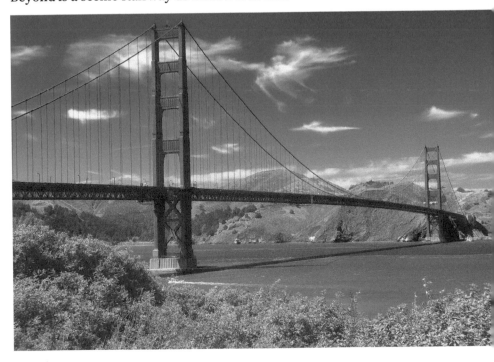

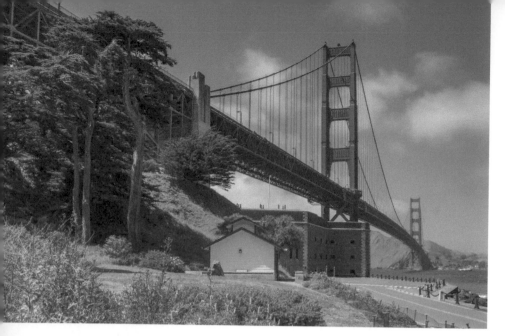

Fort Point is a masonry seacoast fortification under the south side of the bridge.

Replacing a Spanish fort dating from 1794, the fort was built between 1853 and 1861t by the U.S. Army to protect San Francisco Bay against hostile warships.

The approach road along Marina Drive has several cool views of the Bridge.

✉ **Addr:**	Fort Point, San Francisco CA 94129	♥ **Where:**	37.810593 -122.4769
⏱ **When:**	Morning	👁 **Look:**	North-northwest
Ⓦ **Wik:**	Fort_Point,_San_Francisco		

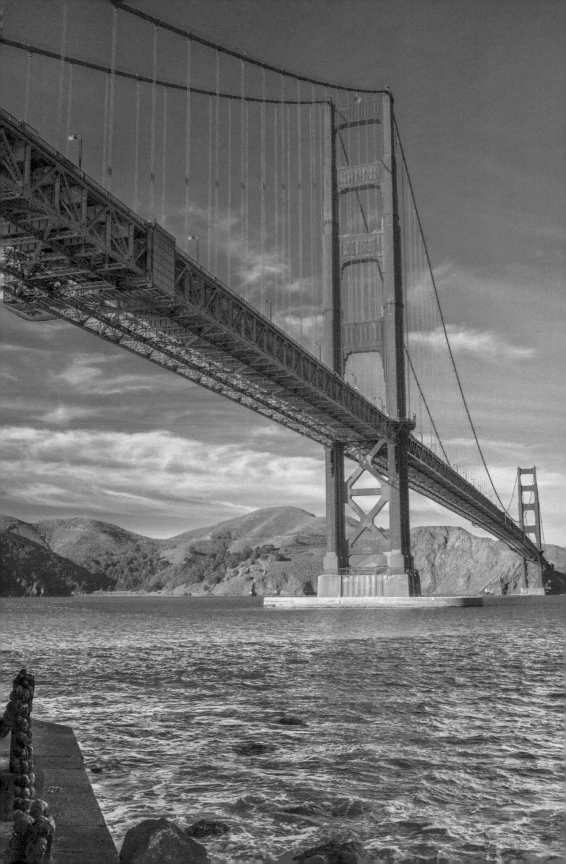

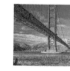

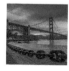

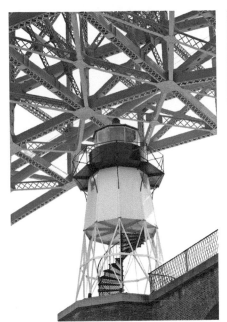

Fort Point is a National Historic Site with a lighthouse and corridors.

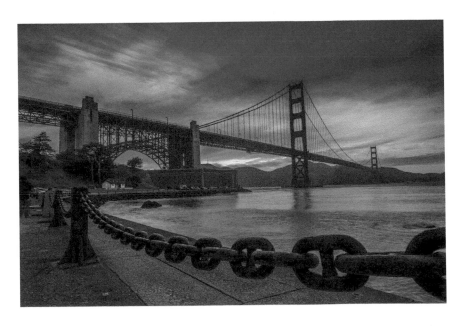

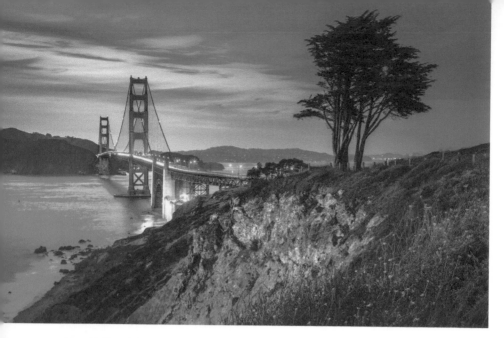

Fort Scott includes five gun batteries dating from the 1890s on the southwest side of the bridge, offering views with bluffs and beaches. From the Welcome Center, you can walk west on the Coastal Trail under the bridge, or drive west on Lincoln Blvd to several parking lots.

Dove Loop around Battery Godfrey has the view above, and the nearby Golden Gate Overlook (below) looks directly north along the roadway of the bridge.

From here you can hike down the Battery to Bluffs Trail to Marshall's Beach.

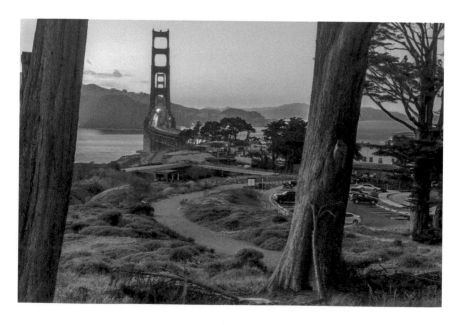

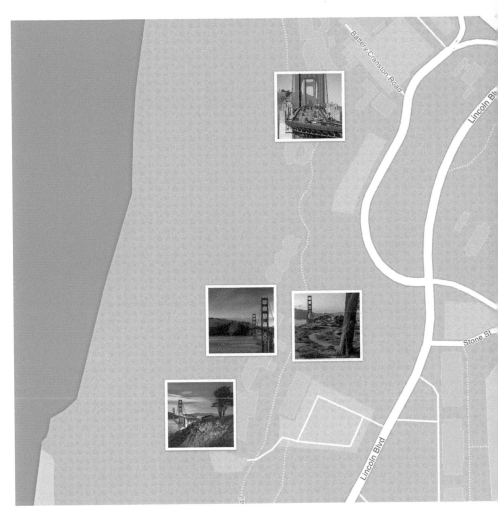

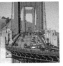 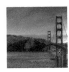 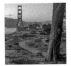

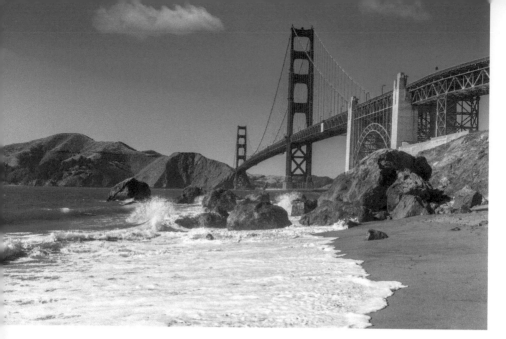

Marshall's Beach is a true "photo secret", a romantic wilderness view with waves crashing on rocks and a sandy beach, where few people go.

The only ways in are to hike down about a mile from Battery Godfrey on the Battery-to-Bluffs Trail (with about 400 feet of stairs), or to clamber over rocks from Baker Beach to the south (you cannot hike from Fort Point in the north).

There are no restrooms and you may want to spend some time here capturing the sunset, so plan ahead. Beware of being caught by the rising tide. If you'll be returning at night, bring a flashlight.

✉ **Addr:**	Marshall's Beach, San Francisco CA 94129	📍 **Where:**	37.8059281 -122.4787765
❓ **What:**	Views	🕐 **When:**	Afternoon
👁 **Look:**	North	↔ **Far:**	1.31 km (0.81 miles)

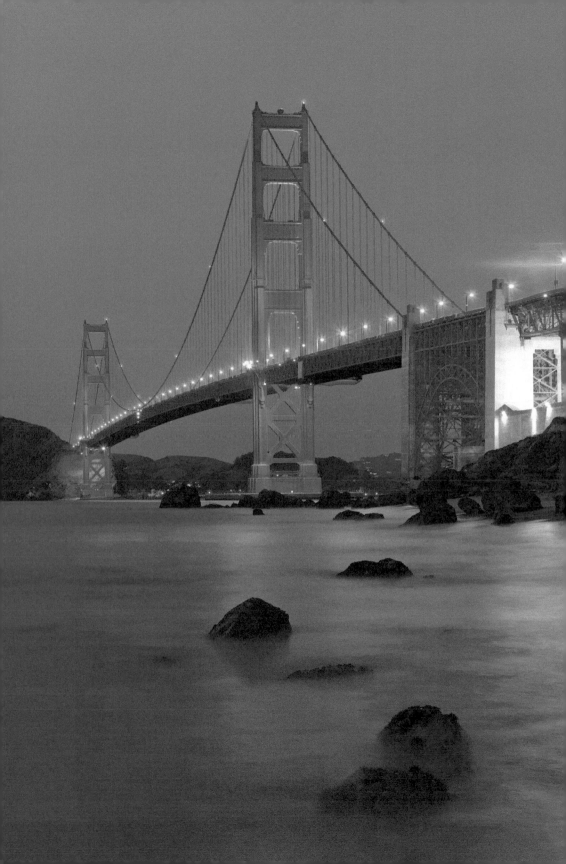

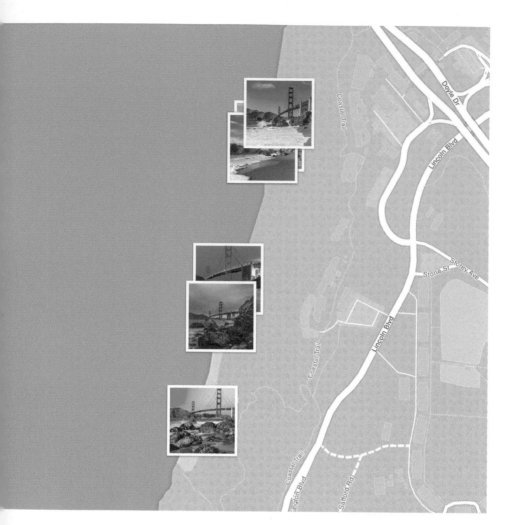

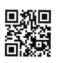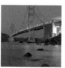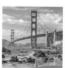

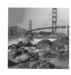

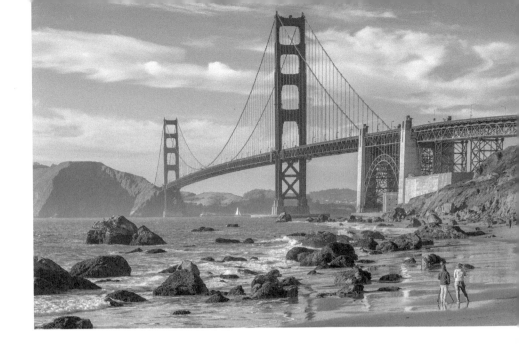

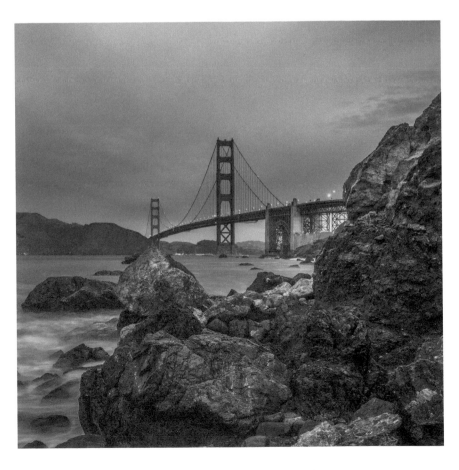

Golden Gate Bridge > south side > southwest > Marshall's Beach

Baker Beach is a longer and more convenient beach to visit than Marshall's Beach (there is a parking lot and restrooms) but the bridge views are less dramatic and more of a romantic backdrop.

Located 1.2 miles (2 km) south of the bridge, the parking lot can be reached from Lincoln Blvd.

✉ **Addr:**	Baker Beach, San Francisco CA 94129	♀ **Where:**	37.7959878 -122.4827989
☽ **When:**	Afternoon	◉ **Look:**	North
↔ **Far:**	2.39 km (1.48 miles)		

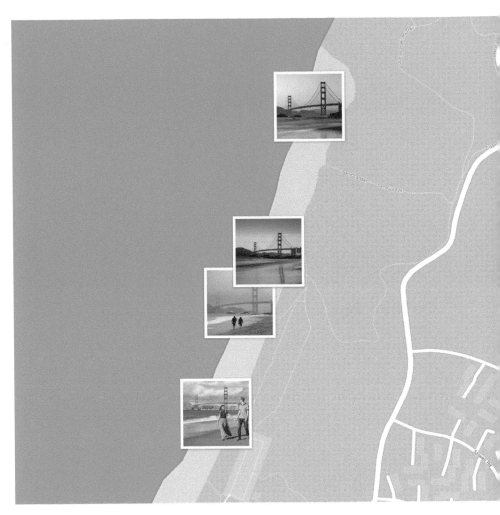

 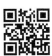 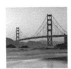 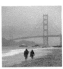

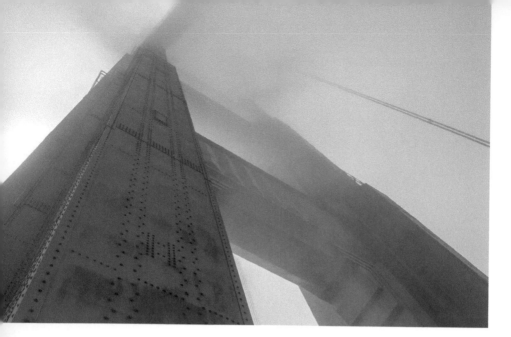

On the bridge, you can take dramatic views looking up the south tower.

From the Welcome Center, walk about half a mile (800 m) north, along a pedestrian path on the east side of the bridge.

Fog helps here, as the leading lines recede into the ether.

✉ **Addr:**	Golden Gate Bridge, San Francisco CA 94129	♀ **Where:**	37.813899 -122.477801
❷ **What:**	Views	◑ **When:**	Morning
👁 **Look:**	North	↔ **Far:**	10 m (33 feet)

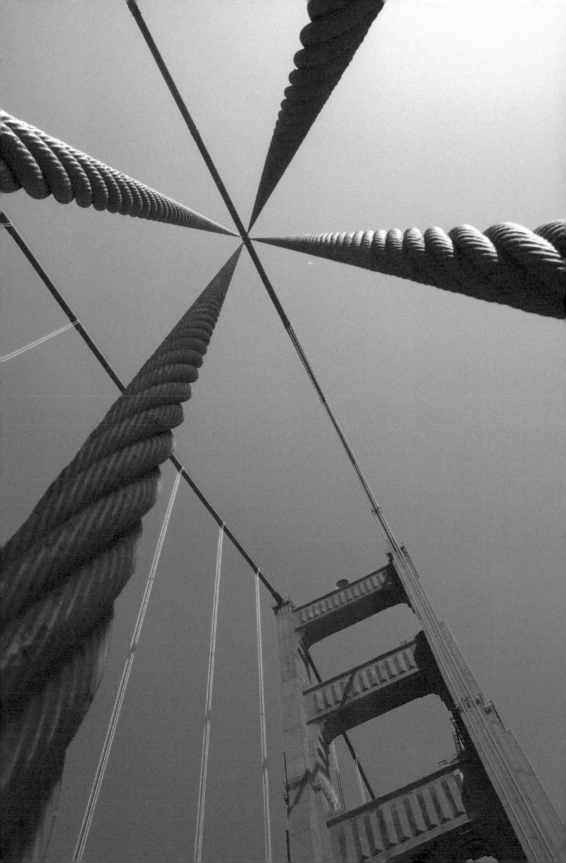

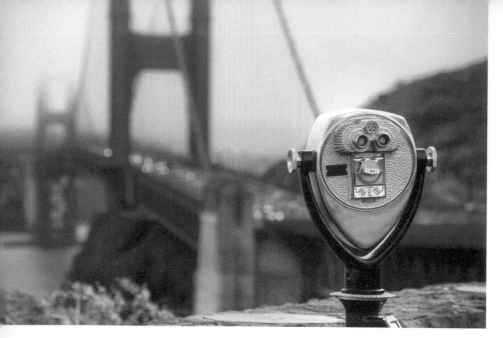

Vista Point is the easiest place to photograph the Golden Gate Bridge on the north side.

Immediately after crossing the bridge, an off ramp leads to a large rest area with parking spaces for cars and buses. A wide overlook offers two views. As shown above, from the east you can get an angle on the bridge and a tower viewer (public binoculars) in the foreground. As shown on the next page, from the west you can photograph straight down the bridge. Since the views are of the east side of the bridge, the best time is morning, or for the car trails, dawn.

You have left the City and County of San Francisco, and entered Marin County. Continuing north, you can visit Marin, Sausalito, Muir Woods and the Wine Country.

✉ **Addr:**	Conzelman Rd, Mill Valley CA 94941	📍 **Where:**	37.832451 -122.479495
❓ **What:**	Overlook	🕐 **When:**	Anytime
👁 **Look:**	South	↔ **Far:**	0.83 km (0.52 miles)

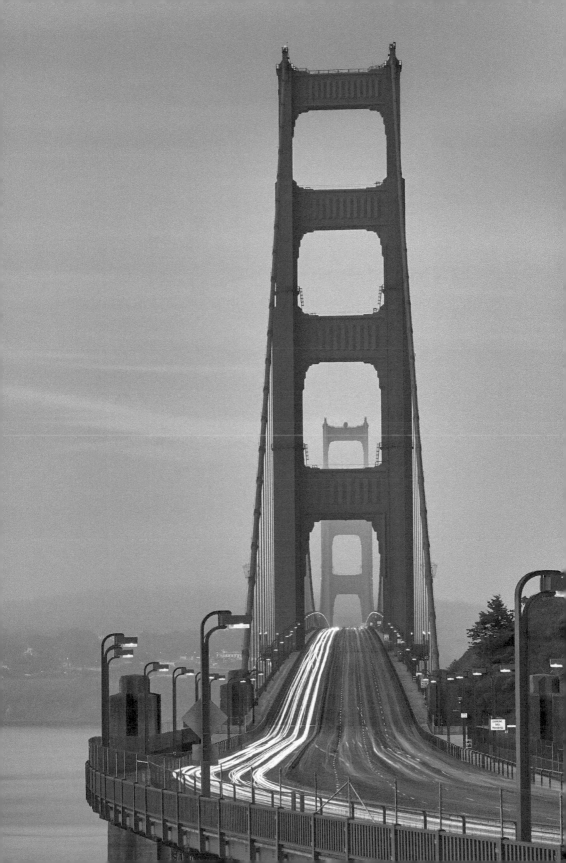

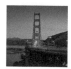

 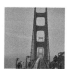 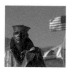

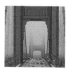

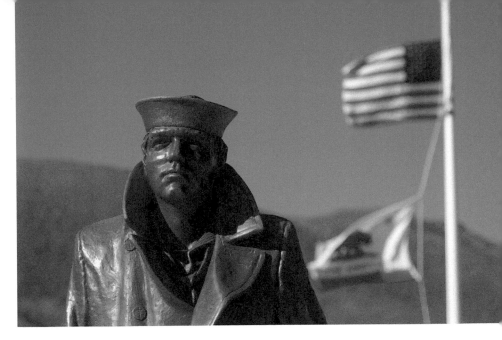

The **Lone Sailor** is a bronze statue honoring all the personnel of the sea services. Stanley Bleifeld sculpted the 1987 original, of which this is a 2002 replica.

The stoic man stands in the center of Vista Point, looking south over the Bay, and can be photographed with the U.S. and California flags behind.

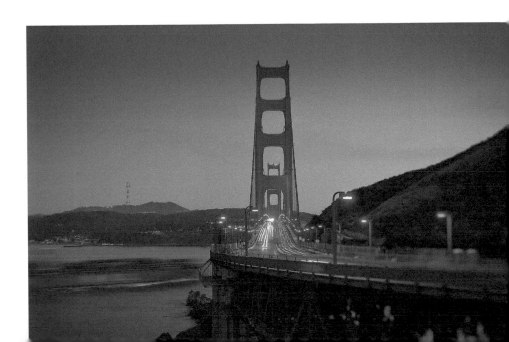

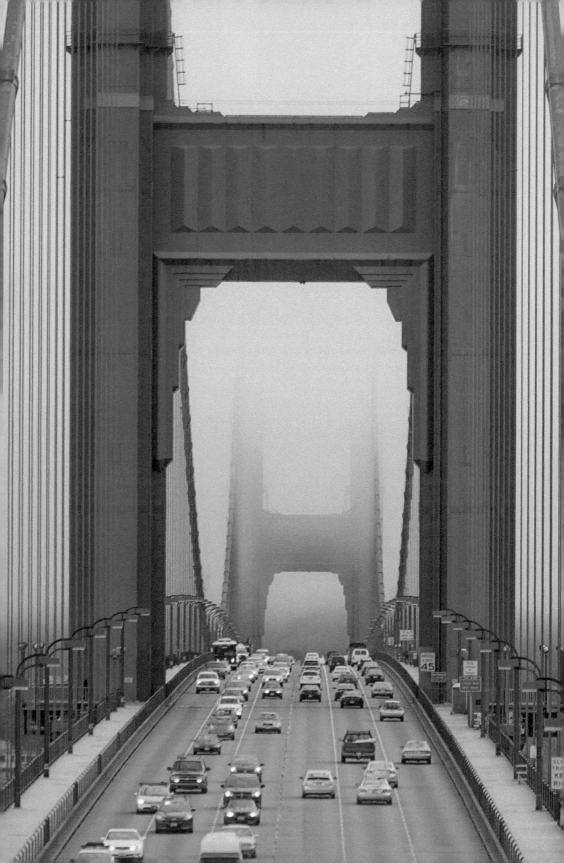

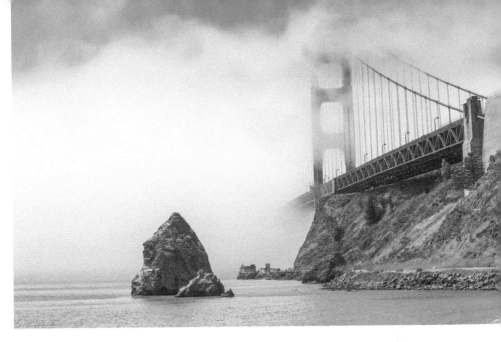

Fort Baker's Moore Road Pier offers a dramatic and lesser-known view, with a pointed rock called Needles in the foreground and an abandoned building on Lime Point to offer scale.

The publicly-accessible pier is below Vista Point, on the west side of Horseshoe Bay. You can also photograph from the east side of the cove, shown here with canoes on the beach by the Presidio Yacht Club, near Point Cavallo.

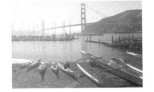

Fort Baker was a military coastal defence from 1850 to the mid-1990s. In the future, it is the home to both Starfleet Headquarters and Starfleet Academy in the Star Trek universe.

✉ **Addr:**	Fort Baker, Sausalito CA 94965	♀ **Where:**	37.831692 -122.477764
◑ **When:**	Morning	◉ **Look:**	South
W **Wik:**	Fort_Baker		

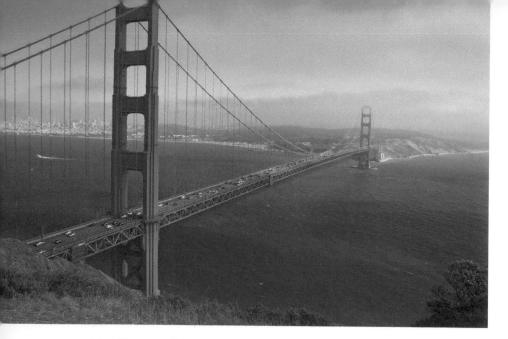

The **Marin Headlands** command the highest and most postcard-worthy views of the Golden Gate Bridge.

From the exit immediately after Vista Point, you can loop around on Alexander Avenue and take Conzelman Road south and west, with about half a dozen classic shots.

The first parking lot is for Battery Spencer, where a short flat walk brings you to a dramatic overlook (above).

After two more parking areas, there is a traffic circle with a small parking area. From here, you can hike about 2/3 mile (1.2 km) up to the ridge on Slackers Hill for the highest possible view.

To frame the Transamerica Pyramid in the north tower, shoot from Conzelman Road about 700 feet (220 m) south of the traffic circle, but note that there is no parking or sidewalk here.

✉ **Addr:**	Marin Headlands, Sausalito CA 94965	♥ **Where:**	37.82778 -122.50611
❓ **What:**	Views	⏲ **When:**	Afternoon
👁 **Look:**	East-southeast	W **Wik:**	Marin_Headlands

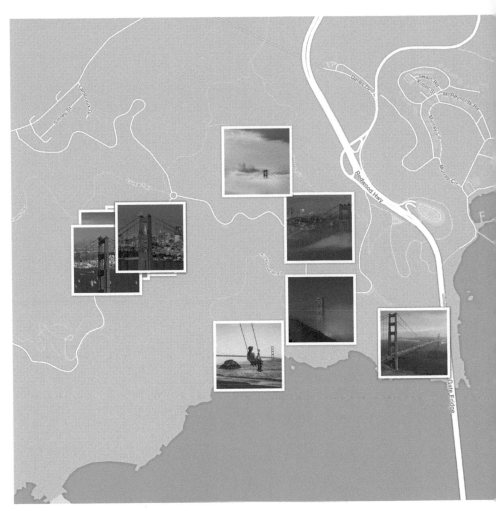

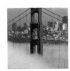

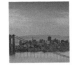
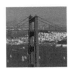
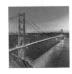
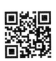

Golden Gate Bridge > north side > Northwest

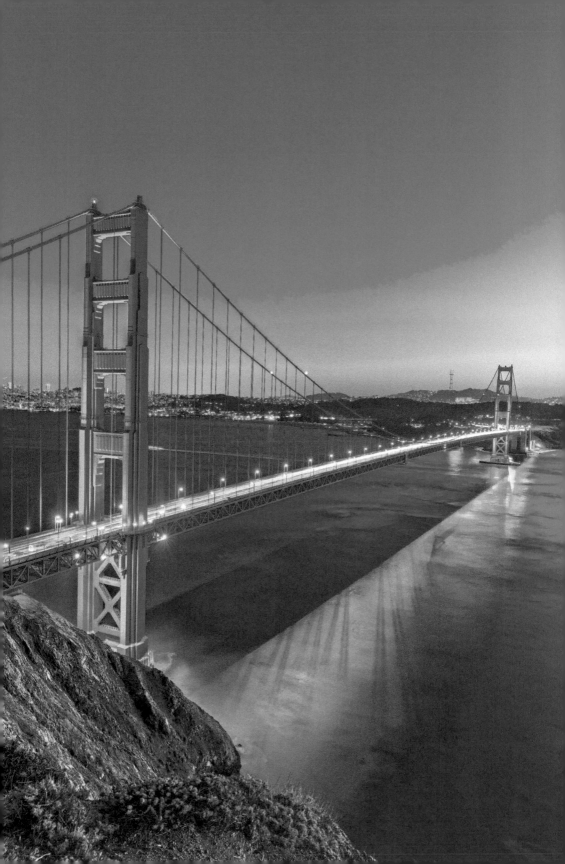

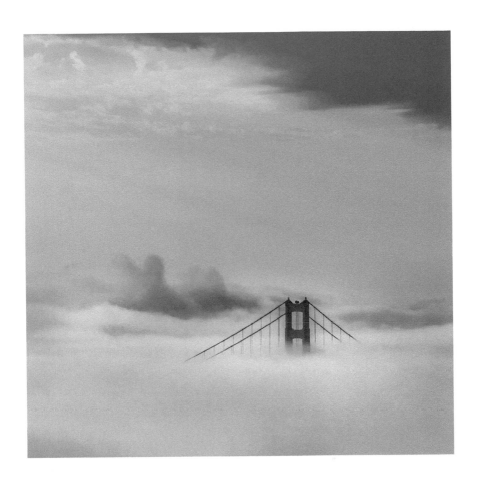

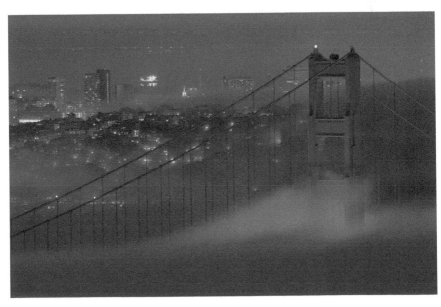

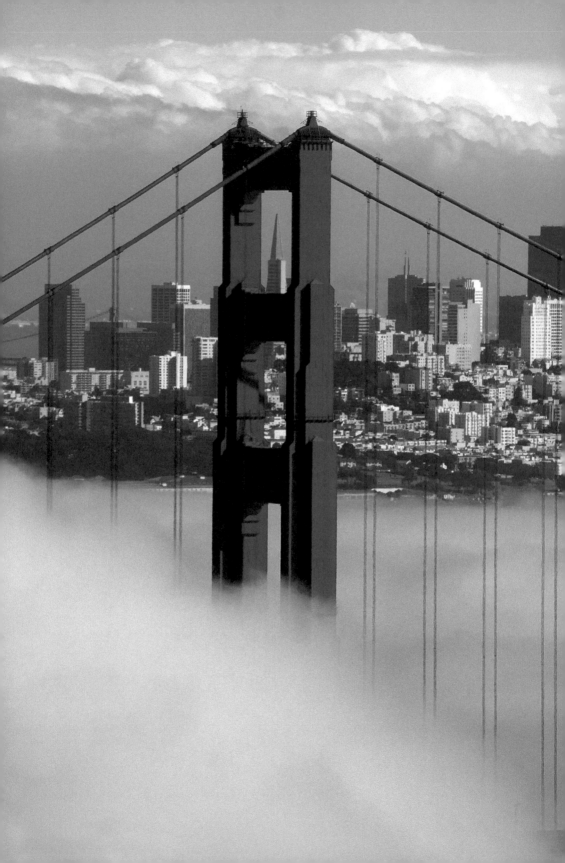

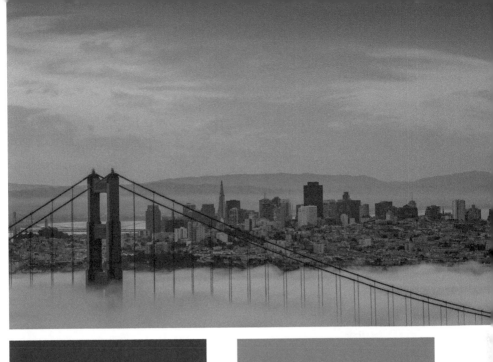

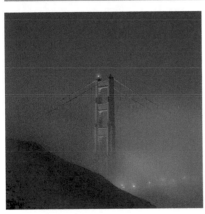

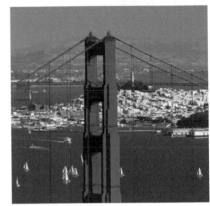

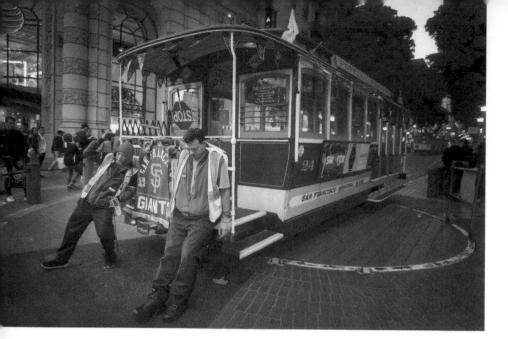

The cable cars of San Francisco provide many photo opportunities. Dating from 1873, the cars are the only ones left in the world that are manually operated, where a "gripman" clamps large locking pliers onto an always-moving cable beneath the street.

There are three lines, two of which run north-south from Fisherman's Wharf and converge at the Powell/Market Turnaround (above). Here, each car on the southbound track is pushed onto a turntable and manually rotated onto the northbound track.

Nearby, are shops and hotels around Union Square (north) and Westfield San Francisco Centre (south).

✉ **Addr:**	Powell at Market, San Francisco CA 94102	📍 **Where:**	37.784710 -122.407700
❓ **What:**	Cable car	🕐 **When:**	Afternoon
👁 **Look:**	North	W **Wik:**	San_Francisco_cable_car_system

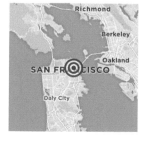

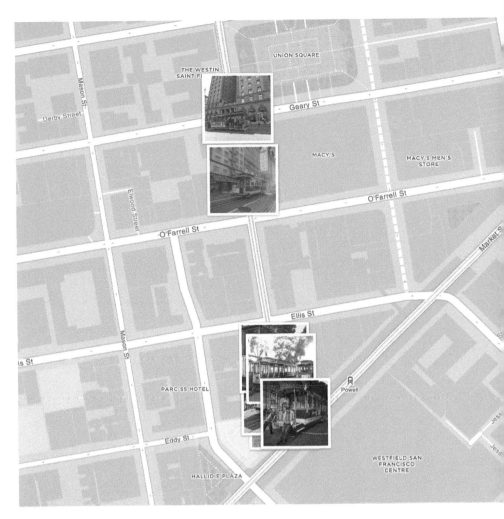

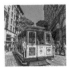

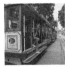

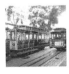

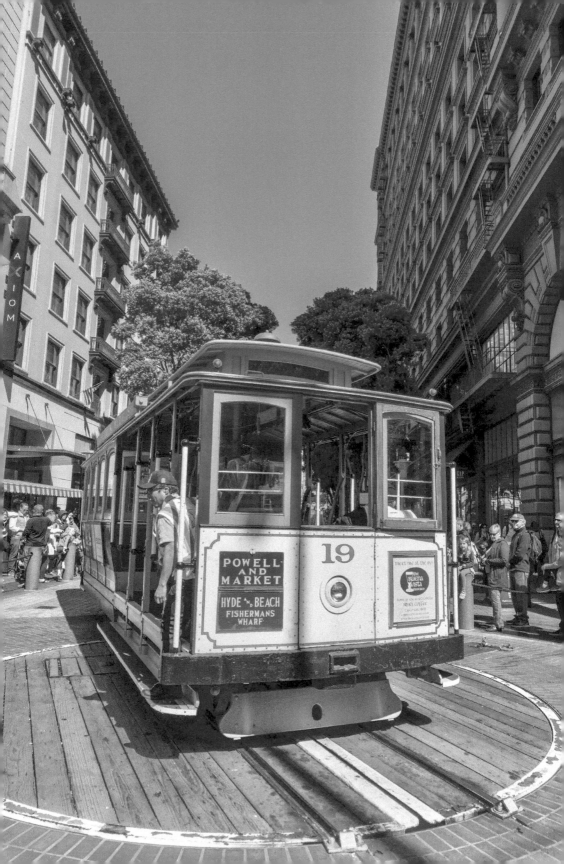

Waiting for the turnaround are cable cars that make a good prop to stage a travel shot. Stand on Powell Street looking north.

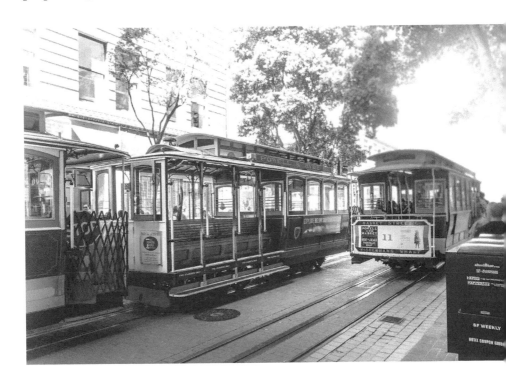

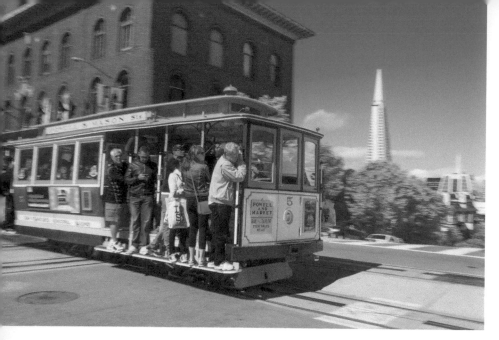

Nob Hill is the only point where all three cable car lines converge. The two north-south Powell lines cross the east-west California Street line at, guess where, Powell and California. Since the Powell cable runs under the California cable, the gripman has to "drop the rope" (release the cable) and let the car coast over the hill, which is the hardest trick on the system. .

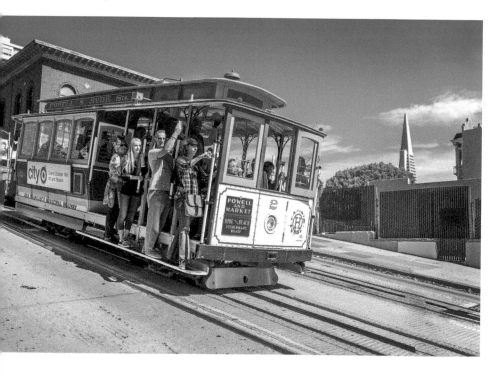

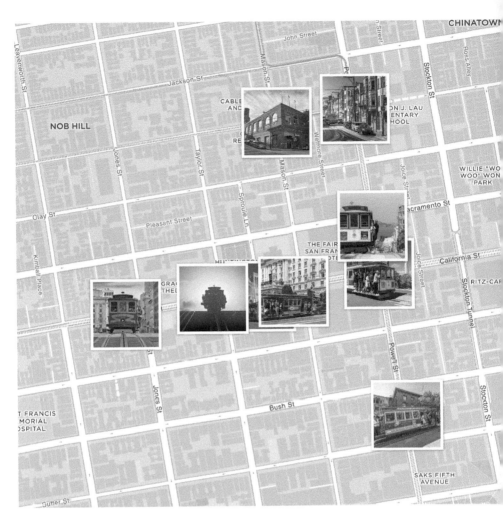

 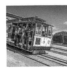 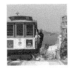

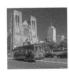 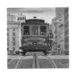

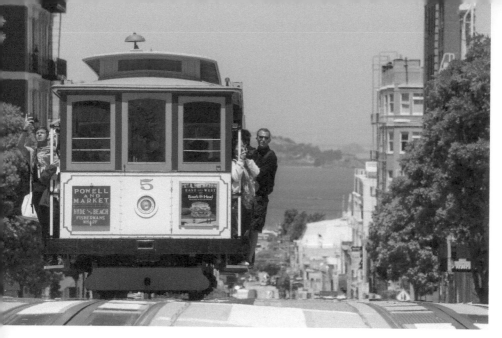

Nob Hill is the highest hill on the system and has several great views.

Above: The Powell lines at Sacramento Street have a backdrop of the San Francisco Bay.

Below: At California and Cushman, you can capture a cable car with Grace Cathedral and Huntington Park, and (not pictured) with the Fairmont Hotel and the Pacific-Union Club (Flood Building).

Right: From California at Jones looking west in the morning you can snap a cable car cresting Nob Hill. .

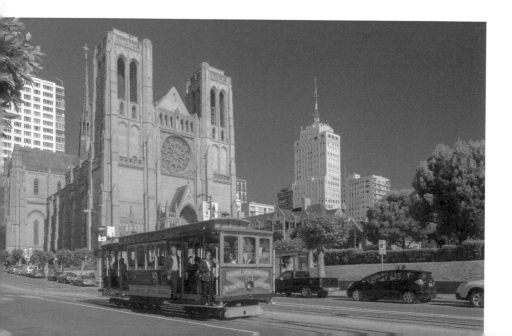

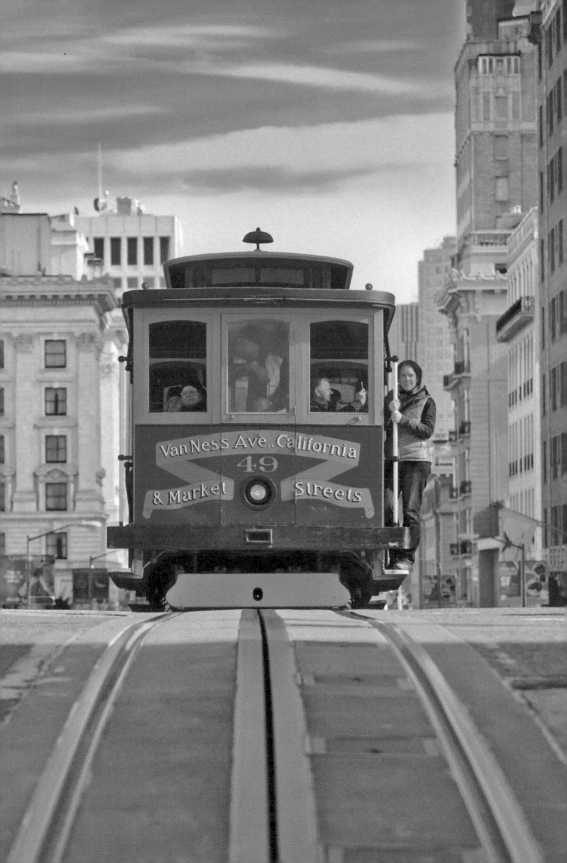

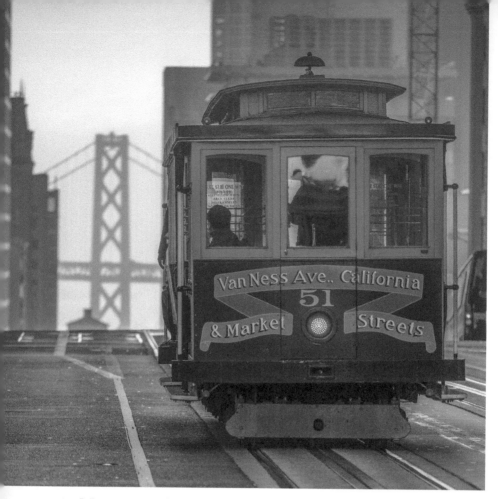

Cables cars with the Bay Bridge can be photographed from several places along California Street.

Above: The view east from California and Taylor Street.

Right: From Mason Street looking east down California Street at sunrise. Two and a half blocks east, nead Sabin Place, you can include a Chinatown building at Grant Street.

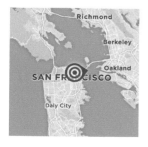
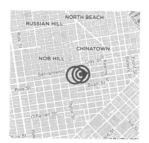

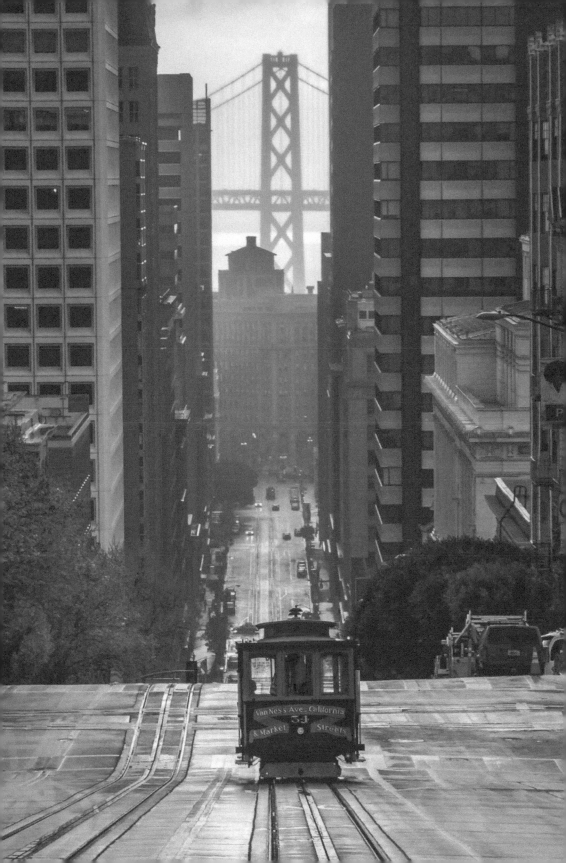

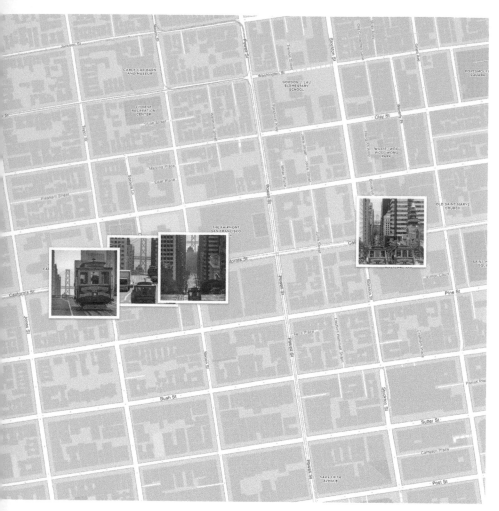

 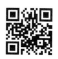 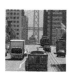

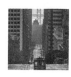 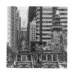

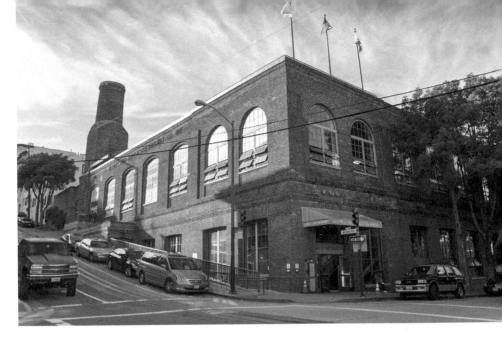

The **San Francisco Cable Car Museum** is a free museum where you can watch the power house pull the cables that pull the cars. You can also descend below the junction of Washington and Mason streets to see the cables routed via large sheaves out to the street.

Two overlook galleries allow you to photograph the huge wheels of the power house.

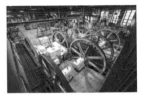

✉ **Addr:**	1201 Mason St, San Francisco CA 94108	♥ **Where:**	37.794503 -122.411318	
❷ **What:**	Museum	◑ **When:**	Anytime	
👁 **Look:**	Northwest	Ⓦ **Wik:**	San_Francisco_Cable_Car_Museum	

The hardest shot in San Francisco is this fabulous silhouette of a cable car against the Bay Bridge at sunrise.

The challenge is trying to get a crisp shot of such a small subject so far away. The cable car is eight feet (2.4 m) wide and it is 2/3 mile (1 km) away, so you'll need a solid tripod.

The photo is taken from California Street at Gough Street in Pacific Heights, near Lafayette Park. You could ride the California Street cable car to the western terminus at Van Ness Avenue and walk two blocks west.

On this hill you are about 30 feet (10 m) below the cable car as it crests Jones Street. You'll need a 600mm lens for a 35mm sensor camera, or the equivalent for your sensor size (for example, a 24mm sensor camera would need a 400mm lens) to get the framing of this photo.

For the silhouette, you'll need to be here in the early morning. To plan when the sun will be exactly in this position, note that California Street is 9° north of east.

Thanks to Jay Huang for taking this shot and making it available.

✉ **Addr:**	California at Gough, San Francisco CA 94109	♀ **Where:**	37.789963 -122.425626
◐ **When:**	Sunrise	◉ **Look:**	East
↔ **Far:**	1.02 km (0.64 miles)		

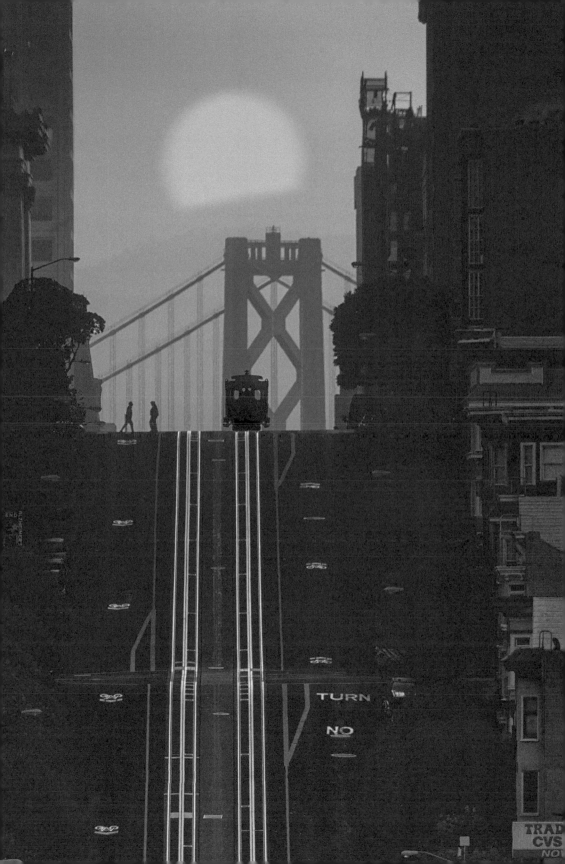

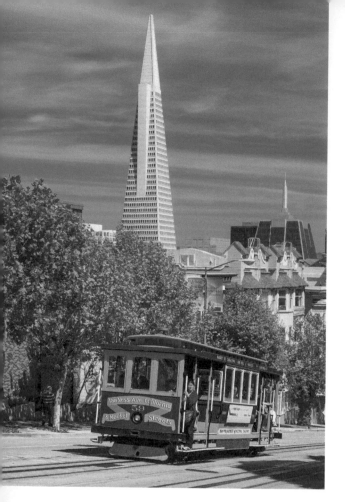

A **cable car with the Transamerica Pyramid** combines two icons of San Francisco.

Stand on the south side of California Street, just downhill from Powell Street, preferably in the afternoon, and wait for a cable car coming up the hill.

✉ **Addr:**	870-896 California St, San Francisco CA 94108	♀ **Where:**	37.792059 -122.408999	
◑ **When:**	Afternoon	◉ **Look:**	East-northeast	
↔ **Far:**	0.65 km (0.40 miles)			

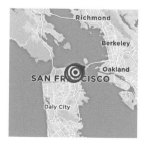 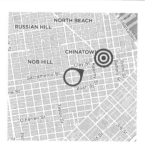

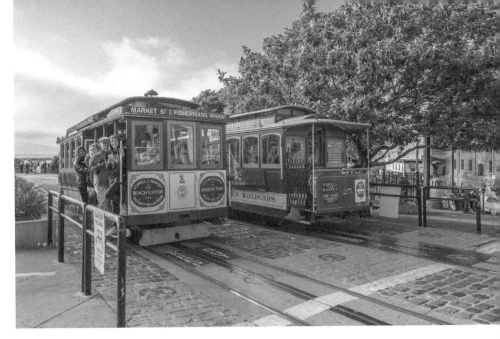

Hyde and Beach Turnaround (officially the Friedel Klussmann Memorial Turnaround) at Fisherman's Wharf is the best area to photograph people riding cable cars. There are cobblestones and the San Francisco Bay in the background.

In the summer, the lines here can be long, so if you're keen to ride a cable car, try the lesser-known turnaround at Powell and Mason, about 1/3 mile (600 m) southwest (take Columbus Ave then Bay Street east).

✉ **Addr:**	2853 Hyde St, San Francisco CA 94109	♀ **Where:**	37.806721 -122.420774	
❓ **What:**	Cable car turnaround	⏲ **When:**	Morning	
👁 **Look:**	North-northwest	↔ **Far:**	15 m (49 feet)	

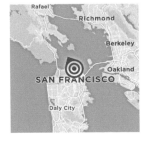
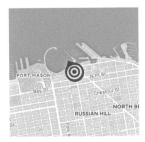

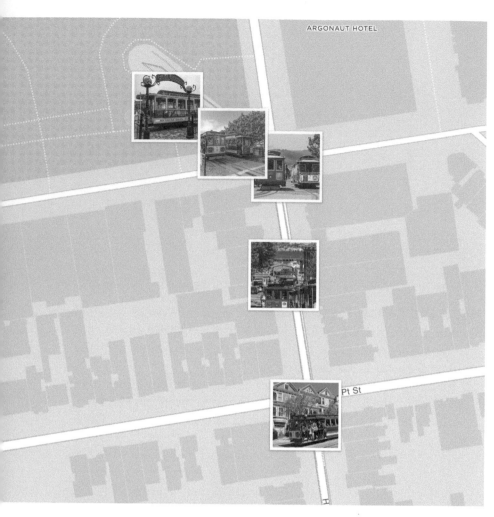

ARGONAUT HOTEL

Pt St

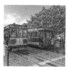

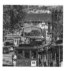

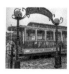

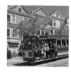

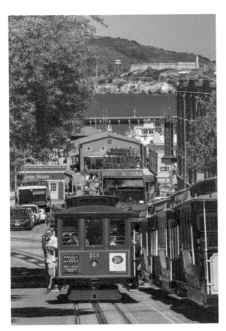
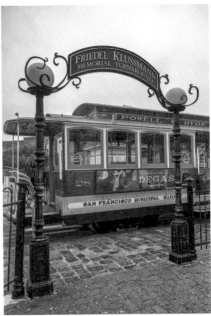

From the tournaround (above right), walk half a block south on Hyde Street and look back (to the north) for a shot of cable cars climbing a hill with the Bay beyond (above left). One block south, past North Point Street, are some Victorian row houses (below) which make a good background.

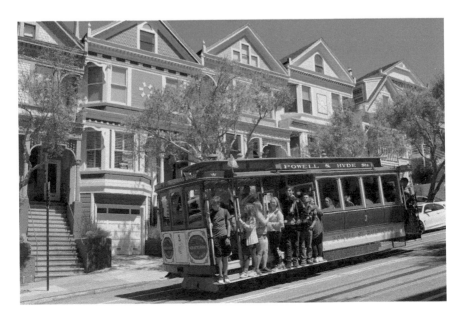

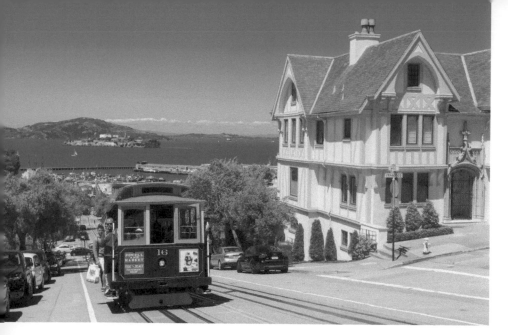

Russian Hill is a picturesque area, as the cable cars climb from Fisherman's Wharf to the top of Lombard Street, the "Crookedest Street in the World.

There are several views on Hyde Street with the San Francisco Bay and Alcatraz in the background.

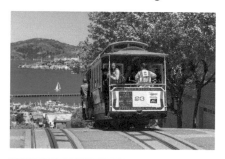
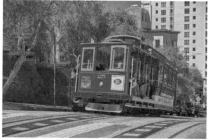

✉ **Addr:**	Hyde at Lombard, San Francisco CA 94109	♀ **Where:**	37.803799 -122.420019
❓ **What:**	Cable car	☾ **When:**	Afternoon
👁 **Look:**	North-northeast	↔ **Far:**	19 m (62 feet)

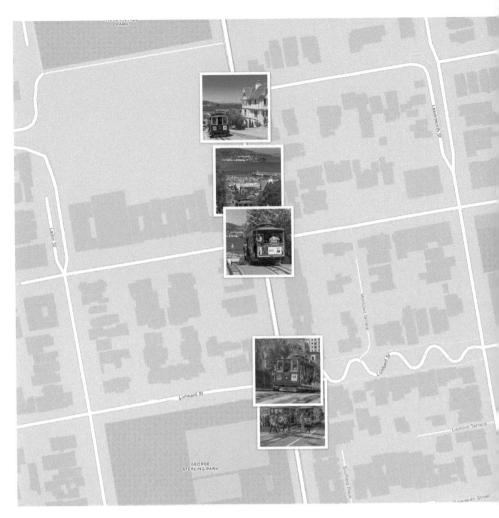

 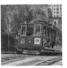 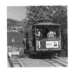

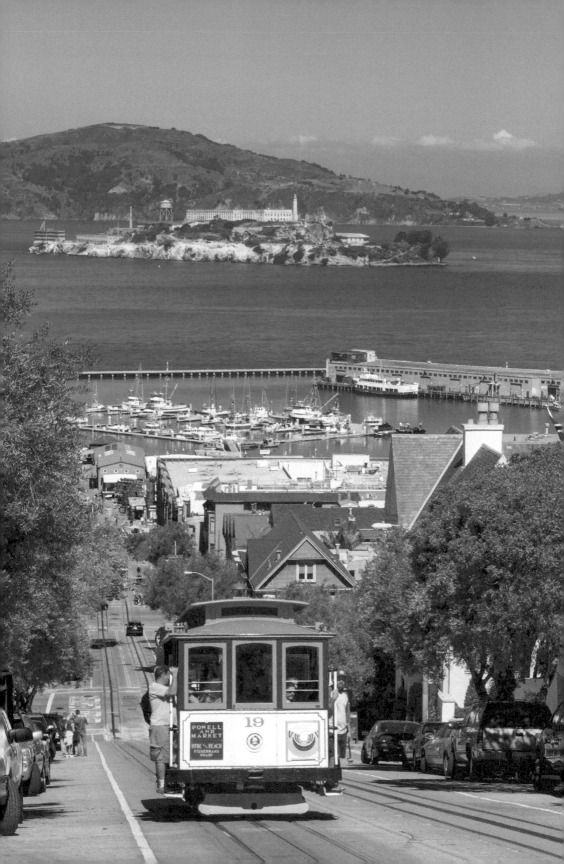

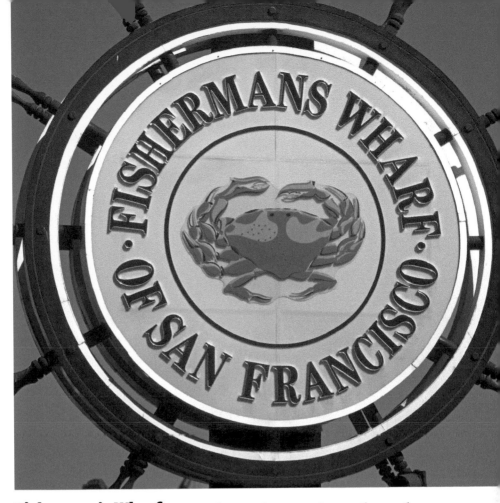

Fisherman's Wharf is a popular tourist attraction on the northern waterfront area of San Francisco, founded in the 1800s by Italian immigrant fishermen.

In the center, at Leavenworth and Jefferson, is a large sign that makes a great establishing shot. Nearby, is Boudin Bakery for sourdough bread novelties and the Musée Mécanique for vintage arcade games.

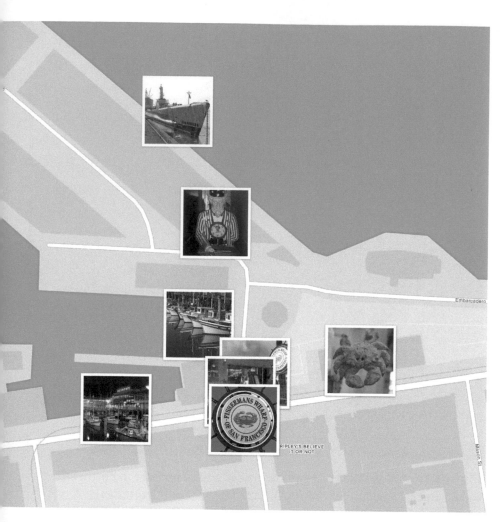

RIPLEY'S BELIEVE
IT OR NOT

Embarcadero

Mason St

 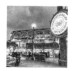 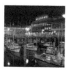

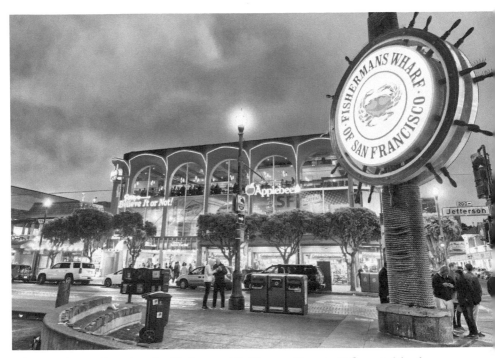

Above: The 21-foot (6 m) tall sign and Jefferson Street. *Below:* A block west, you can photograph the still-active fishing fleets from Jefferson Street near Jones Street, with Alioto's restaurant in the background.

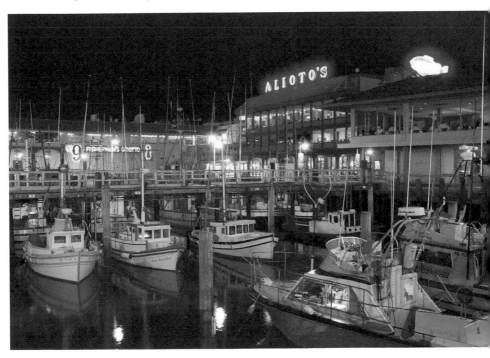

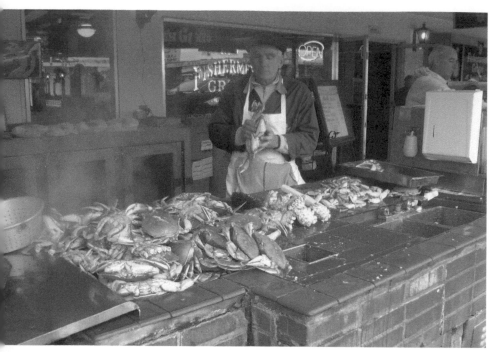

Opposite the sign at Leavenworth Street is a row of open-air stalls selling locally-caught Dungeness crabs, so you can literally get a taste of the area.

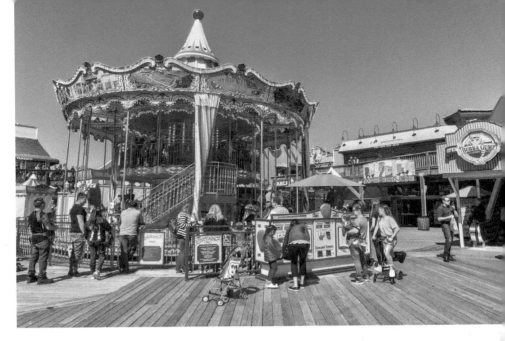

Pier 39 is a shopping center on a pier. In the center is a two-story carousel (above) and the entrance features a large crab statue and a Hard Rock Cafe (below). The most adorable shots in San Francisco can be taken at the northwest corner, overlooking California sea lions hauled out on marina docks.

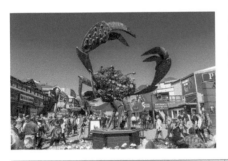
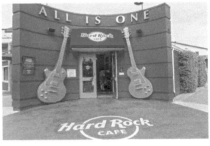

✉ **Addr:**	Fishermans's Wharf, San Francisco CA 94133	♀ **Where:**	37.8105783 -122.4106583
❷ **What:**	Pier	◑ **When:**	Morning
👁 **Look:**	South-southwest	W **Wik:**	Pier_39

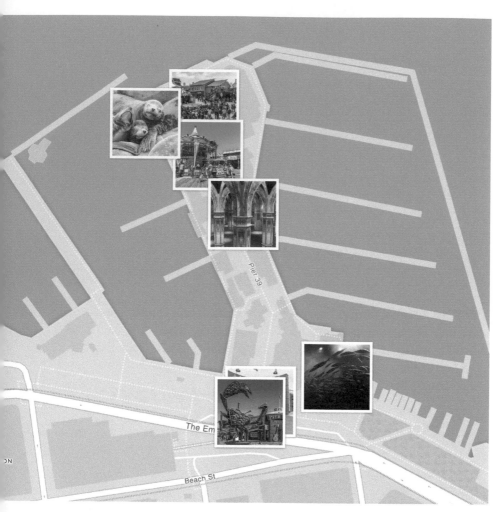

 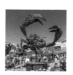

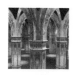 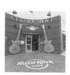

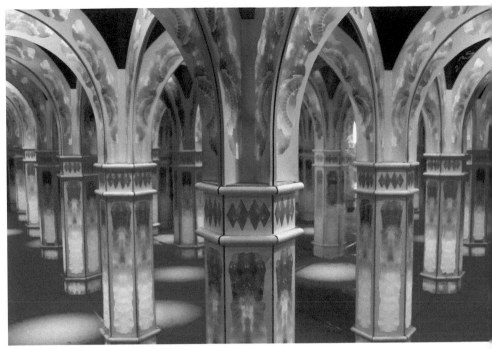

Above: Magowan's Infinite Mirror Maze [paid admission] makes for colorful indoor photos, but good luck finding your way out.
Below: The Aquarium of the Bay [paid admission].

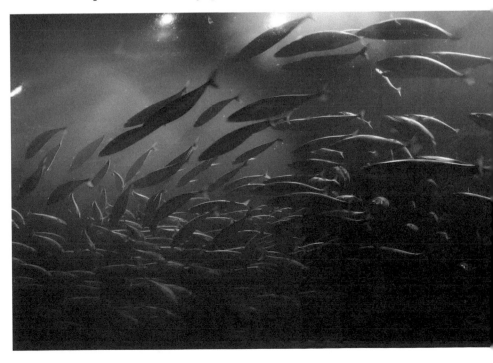

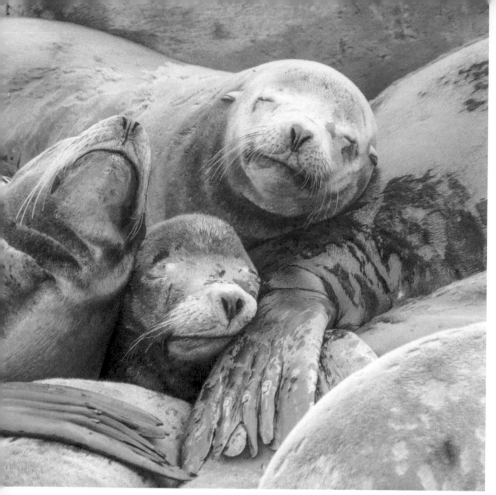

Sea lions photographed from the northwest end of Pier 39.

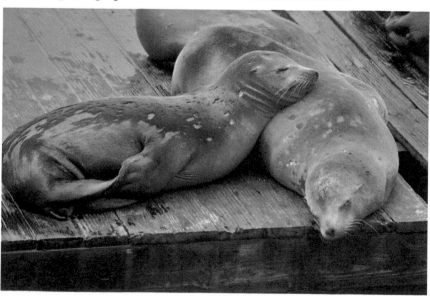

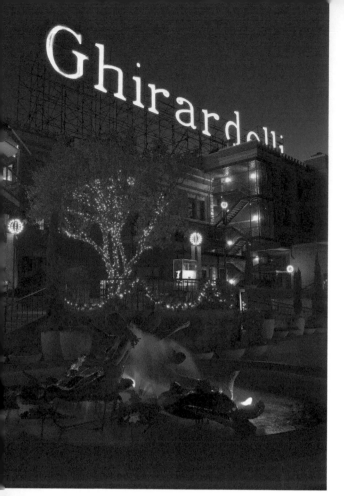

Ghirardelli Square is a landmark public square with restaurants and a chocolate shop.

In 1893, Domenico Ghirardelli purchased the entire city block for the headquarters of the Ghirardelli Chocolate Company. When the company moved in 1962, the square and its historic brick structures were converted to an integrated restaurant and retail complex.

✉ **Addr:**	900 North Point St, San Francisco CA 94109	♀ **Where:**	37.805987 -122.422506
❓ **What:**	Building	🕐 **When:**	Anytime
👁 **Look:**	South-southwest	W **Wik:**	Ghirardelli_Square

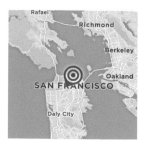
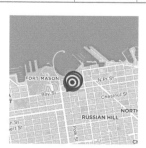
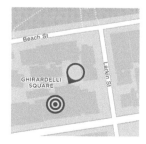

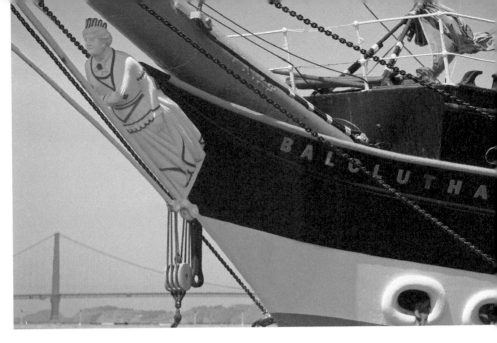

Balclutha is a steel-hulled, full-rigged ship built in 1886 used to transport lumber, salmon, and grain.

Built in Glasgow, Scotland, as a general trader, Balclutha rounded Cape Horn 17 times in thirteen years. After 1904, she was renamed Star of Alaska and sailed from the San Francisco area to the Chignik Bay, Alaska, in April with supplies, fishermen, and cannery workers, returning in September with a cargo of canned salmon.

Balclutha starred in the 1935 film *Mutiny on the Bounty* starring Clark Gable and Charles Laughton.

✉ **Addr:**	Hyde Street Pier, San Francisco CA 94109	♀ **Where:**	37.809598 -122.422016
❓ **What:**	Ship	◑ **When:**	Morning
👁 **Look:**	West	W **Wik:**	Balclutha_(1886)

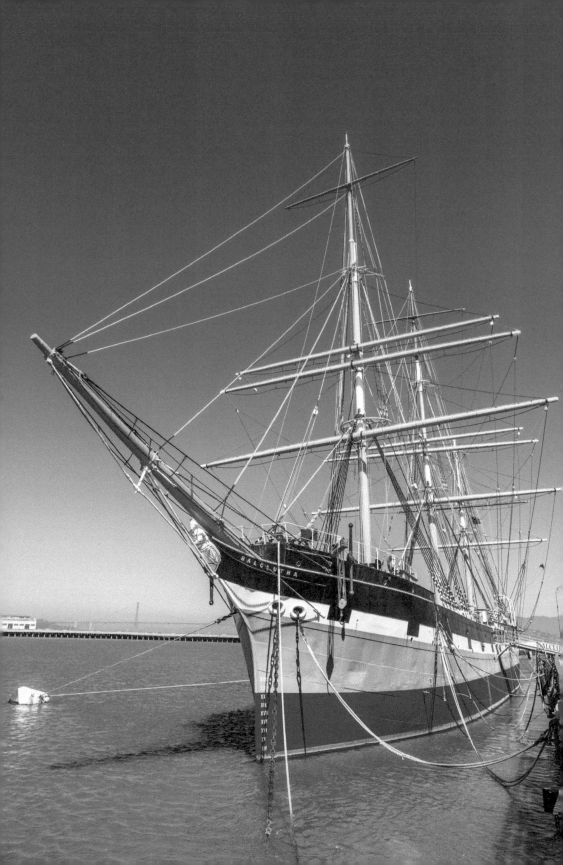

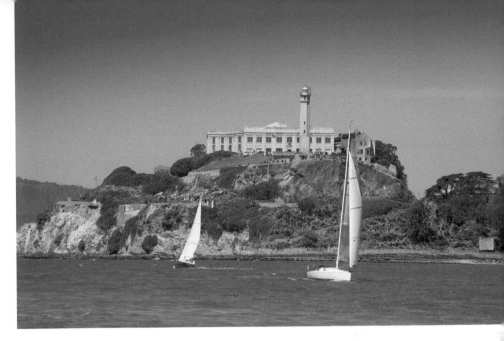

Alcatraz was the nation's most secure federal prison from 1934 to 1963. Once home to Al Capone, "Machine Gun" Kelly and the "Birdman of Alacatraz" Robert Stroud, "The Rock" is now a National Park Service property awaiting your exploration.

Access is only by paid tours via ferry on Alcatraz Cruises, from Pier 33, on the Embarcadero east of Fisherman's Wharf. Tickets often sell out so make reservations as early as you can, up to 90 days in advance, at alcatrazcruises.com.

✉ **Addr:**	San Francisco Bay, San Francisco CA 94133	♀ **Where:**	37.826574 -122.422752
❷ **What:**	Former prison	◑ **When:**	Afternoon
👁 **Look:**	North	W **Wik:**	Alcatraz_Island

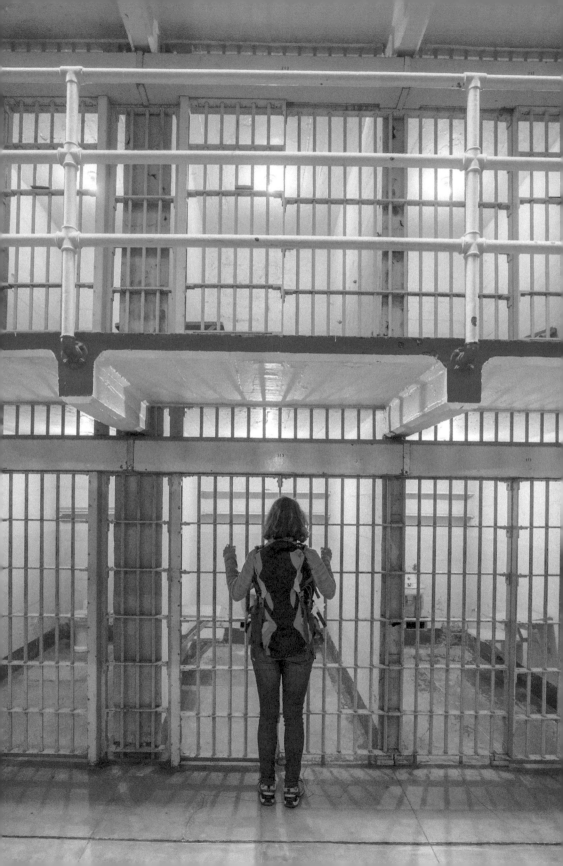

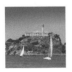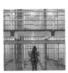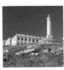

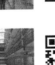

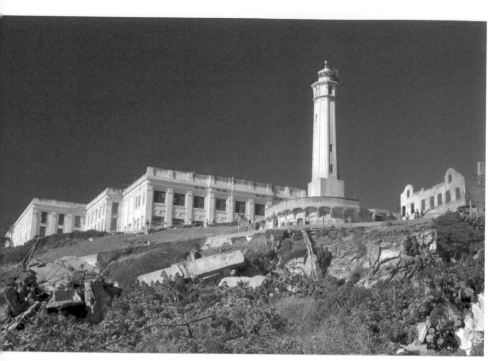

Above: The lighthouse is the oldest operating lighthouse on the West Coast. This view is from the south, by the Parade Ground. *Below:* The Recreation Yard, from the northwest corner.

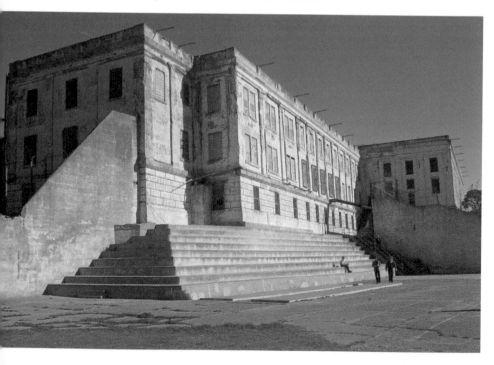

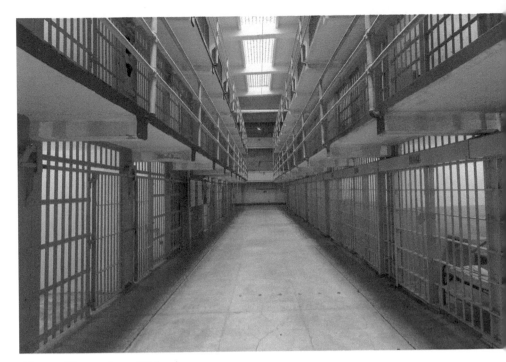

Above: The main cell block.
Below: The Laundry Building.

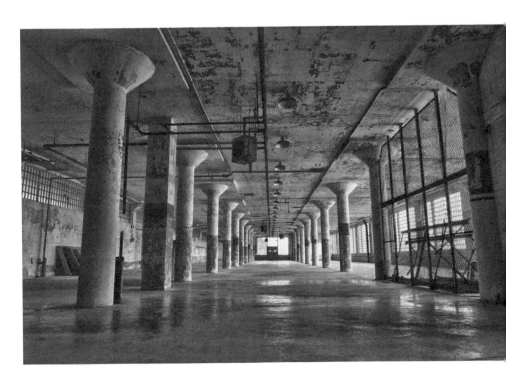

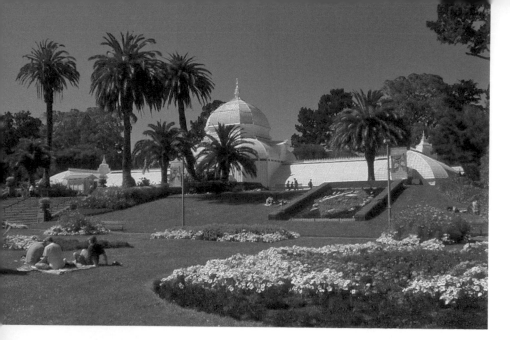

Golden Gate Park is a three-mile-long (4.8 km) city park, founded in 1871. The signature building is the **Conservatory of Flowers**, constructed in 1878 — the oldest building in the park and the oldest remaining municipal wooden conservatory in the country.

The elaborate Victorian greenhouse was inspired by the Palm House in Kew Gardens, London and has a central dome rising nearly 60 feet (18 m) high and arch-shaped wings extending from it for an overall length of 240 feet (73 m).

Inside are rare and exotic plants including orchids and carnivorous plants.

✉ **Addr:**	100 John F Kennedy Dr, San Francisco CA 94118	♥ **Where:**	37.772006 -122.459595
❓ **What:**	Conservatory	◑ **When:**	Morning
👁 **Look:**	Northwest	W **Wik:**	Conservatory_of_Flowers

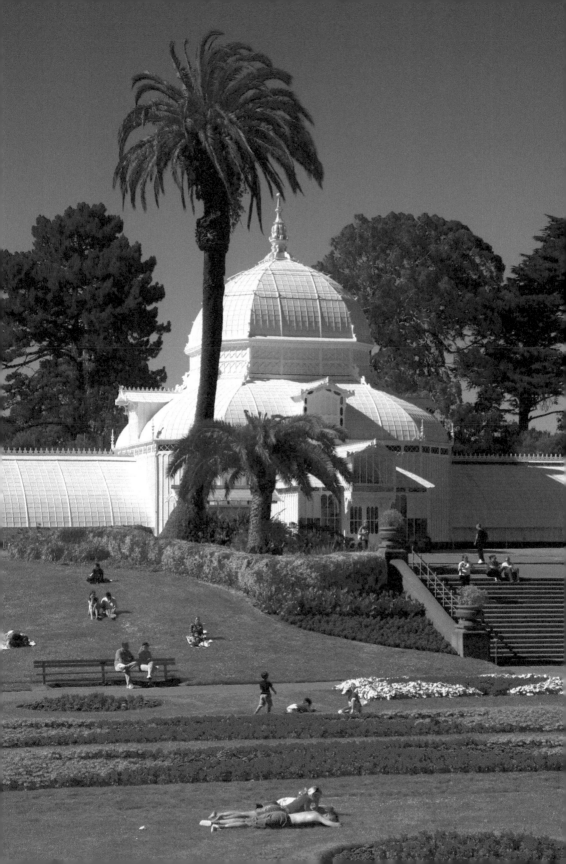

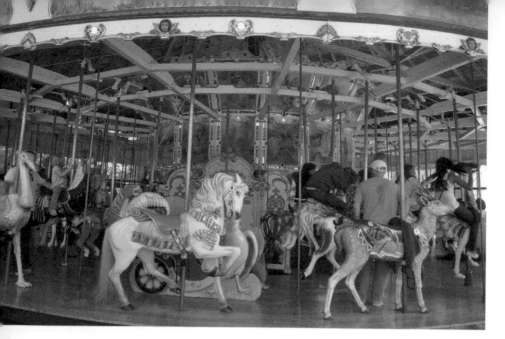

Golden Gate Park Carousel is a 1914 Herschell-Spillman, installed in Golden Gate Park in 1940. The carousel's 62 colorfully painted menagerie animals include a dragon, camel, and goat as well as horses, frogs, dogs, roosters, and pigs.

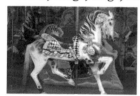

The Carousel is in the southeast corner of the park, in the Koret Children's Quarter (formerly the Children's Playground).

✉ **Addr:**	320 Bowling Green Drive, San Francisco CA 94118	♀ **Where:**	37.76805 -122.458053
❓ **What:**	Carousel	◑ **When:**	Afternoon
👁 **Look:**	South	↔ **Far:**	16 m (52 feet)

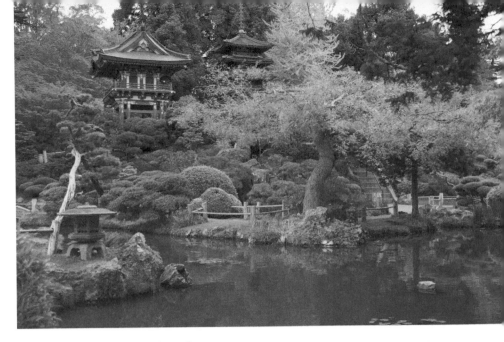

The **Japanese Tea Garden** is a popular attraction originally built for an 1894 world's fair and now the country's oldest public Japanese garden.

The main pond (above) has views of two red towers — the Temple Gate (left) and Pagoda (right).

✉ **Addr:**	75 Hagiwara Tea Garden Drive, San Francisco CA 94118	♀ **Where:**	37.769794 -122.469929
❓ **What:**	Garden	⏱ **When:**	Morning
👁 **Look:**	Northwest	Ⓦ **Wik:**	Japanese_Tea_Garden_(San_Francisco,_California)

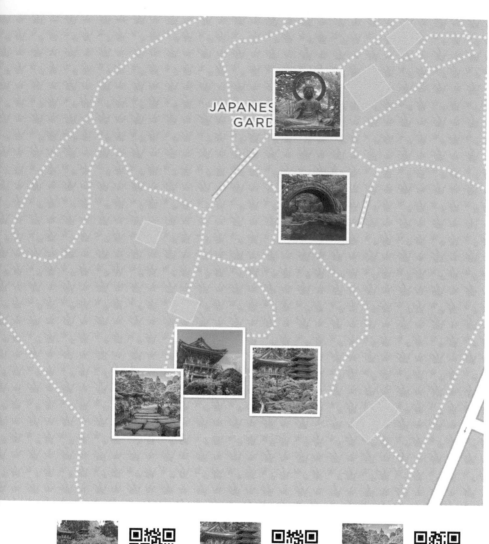

JAPANES
GARD

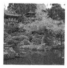 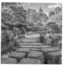

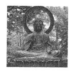

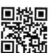

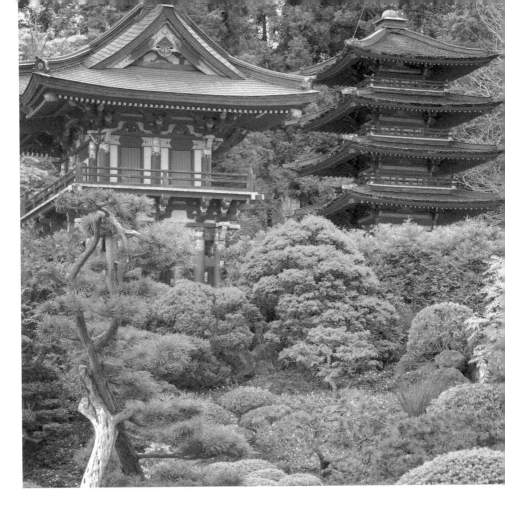

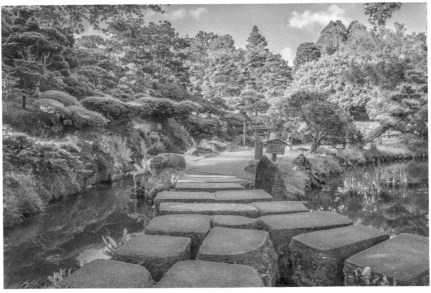

Golden Gate Park > Music Concourse area > Japanese Tea Garden 87

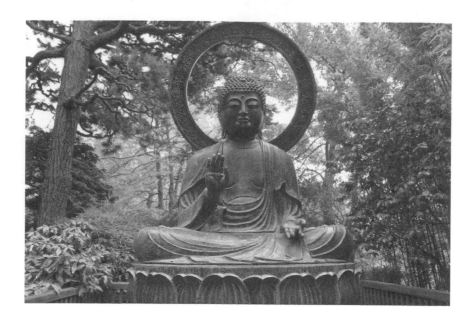

Above: Amazarasti-No Hotoke is a seated bronze Buddha on lotus leaf. The title means "The Buddha that sits throughout the sunny and rainy weather without shelter."
Below: The wooden Moon Bridge is a semi-circle, making a circle with its reflection.

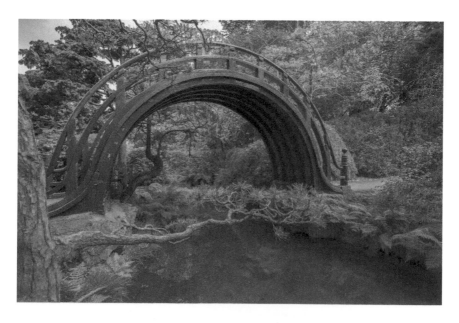

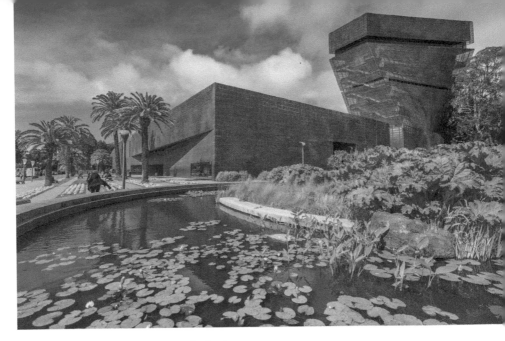

M. H. de Young Memorial Museum, commonly referred as the **de Young**, is a fine arts museum named for its founder, early San Francisco newspaperman M. H. de Young. Founded in 1895, the museum is housed in a 2005 building entirely clad in copper. On the north corner is the twisting Hamon Tower, 144 ft. (44 m) high with an observation deck with free access.

The Osher Sculpture Garden [paid admission] includes a giant safety pin, called *Corridor Pin, Blue* (1999) by Claes Oldenburg and Coosje van Bruggen.

In front of the museum, facing the Music Concourse, are two sphinx sculptures, a koi pond, and a Keith Haring sculpture called *Three Dancing Figures*.

✉ **Addr:**	50 Hagiwara Tea Garden Dr, San Francisco CA 94118	♀ **Where:**	37.771657 -122.467549
❷ What:	Museum	**◔ When:**	Morning
👁 Look:	West	W **Wik:**	M._H._de_Young_Memorial_Museum

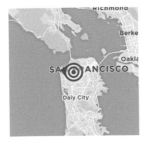
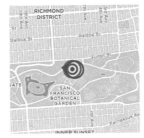

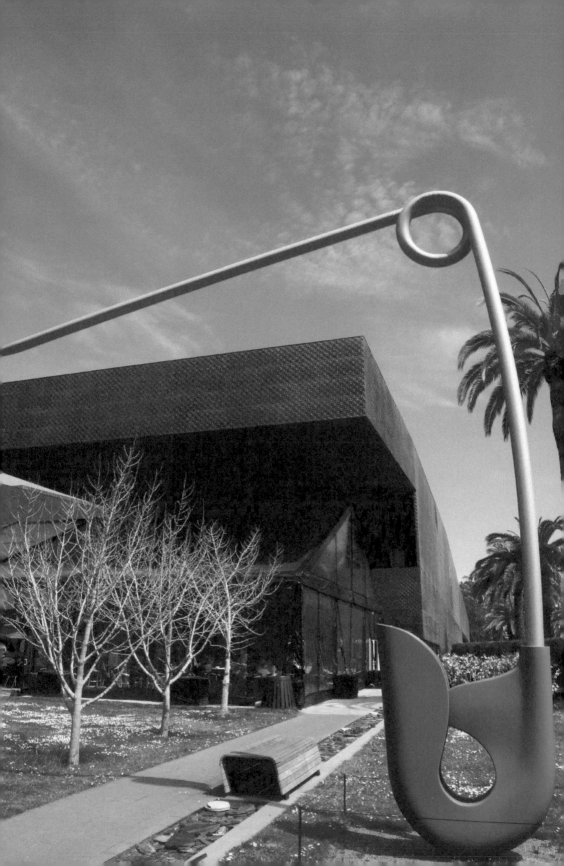

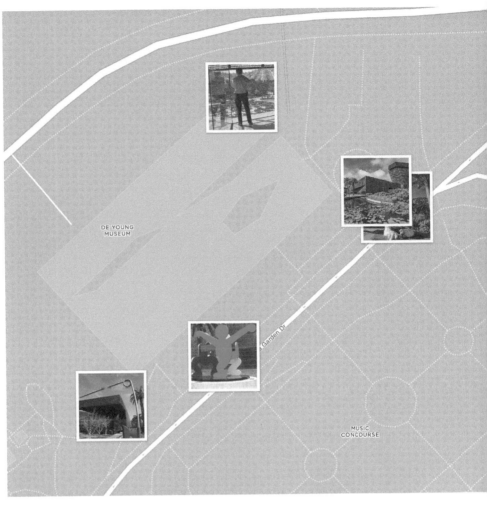

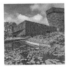

 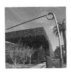

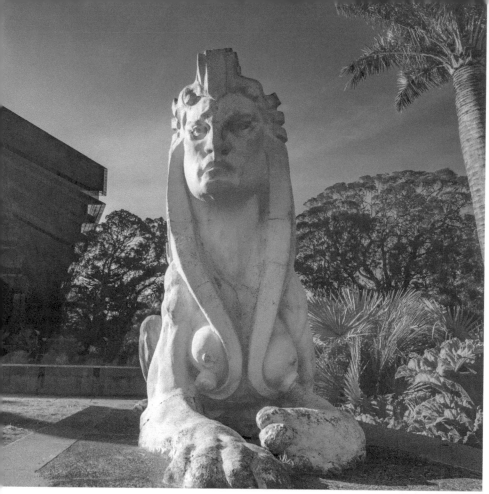

A sphinx sculpture and *Three Dancing Figures* by Keith Haring.

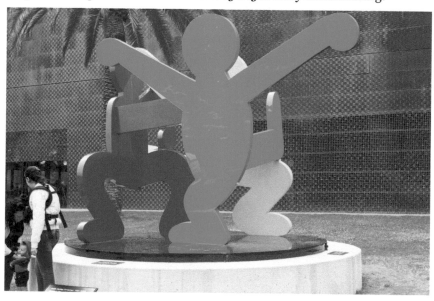

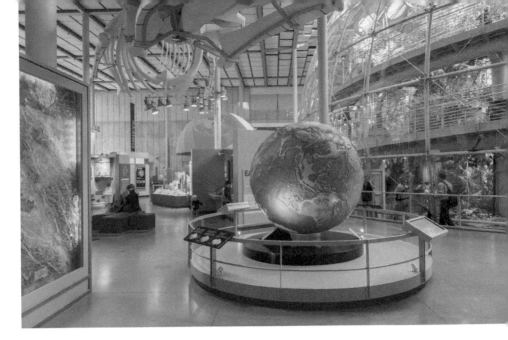

The **California Academy of Sciences** (CAS) started in 1853 and is California's oldest museum. Completely rebuilt in 2008, the building includes a raised relief globe (above) and the largest spherical rainforest exhibit in the world.

✉ **Addr:**	55 Music Concourse Drive, San Francisco CA 94118	♀ **Where:**	37.769207 -122.466289
❷ **What:**	Museum	☽ **When:**	Morning
👁 **Look:**	North	W **Wik:**	California_Academy_of_Sciences

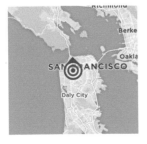
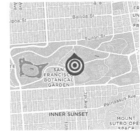
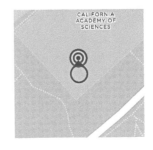

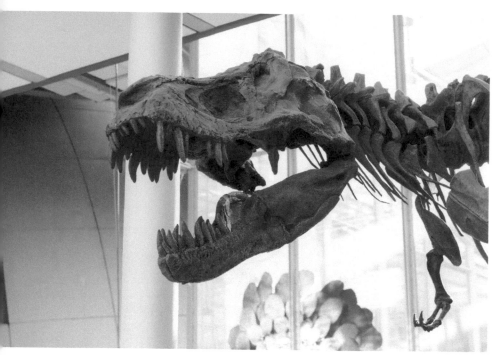

Above: Tyrannosaurus rex skeleton.
Below: Philippine coral reef tank.

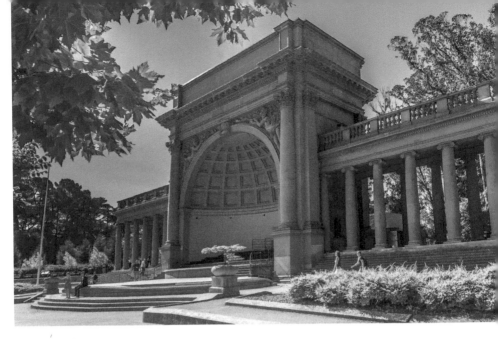

The **Music Concourse** is an open-air plaza and music venue, between the California Academy of Sciences and the M. H. de Young Memorial Museum.

The focal point is the Spreckels Temple of Music, a large neoclassical bandshell built in 1899.

Around the Music Concourse are busts of Beethoven and Verdi, and an eclectic range of sculptures.

✉ **Addr:**	Golden Gate Park, San Francisco CA 94118	♀ **Where:**	37.770104 -122.468518
❷ What:	Concourse	**⏲ When:**	Morning
👁 Look:	South	**W Wik:**	Music_Concourse

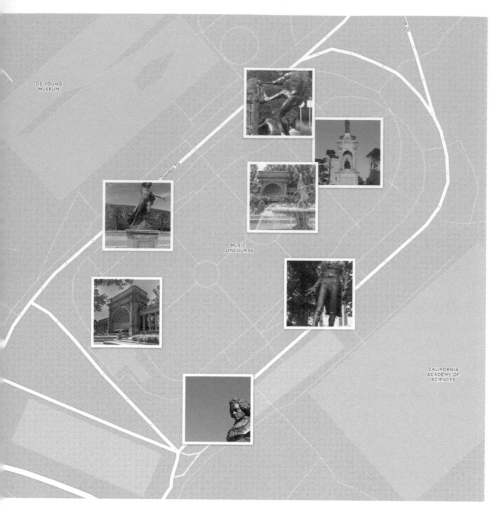

Above left: The Francis Scott Key Monument honors the writer of *The Star-Spangled Banner. Above right:* Robert Emmet, the Irish patriot. *Below left:* The Cider Press (1893) by Thomas Shields Clarke. *Below right:* Leonidas, the Greek hero-king of Sparta, by Guillaume Geefs, 1894.

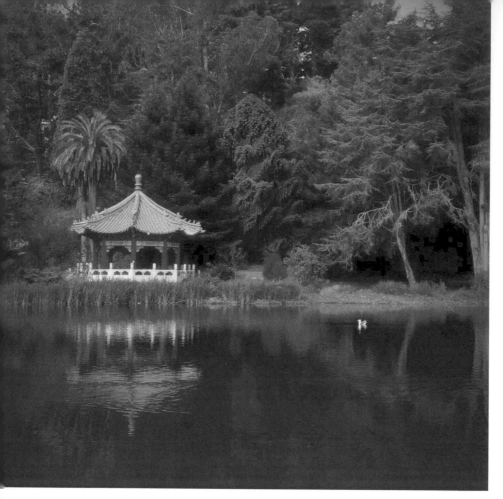

Stow Lake is west of the Music Concourse an features a **Chinese Pavilion** on an island. A gift from Taipei, Taiwan in 1981, the pavilion can be photographed from the east shore of Stow Lake.

✉ **Addr:**	Golden Gate Park, San Francisco CA 94118	⚲ **Where:**	37.768424 -122.472891
❓ **What:**	Pavilion	🌒 **When:**	Morning
👁 **Look:**	West	↔ **Far:**	60 m (210 feet)

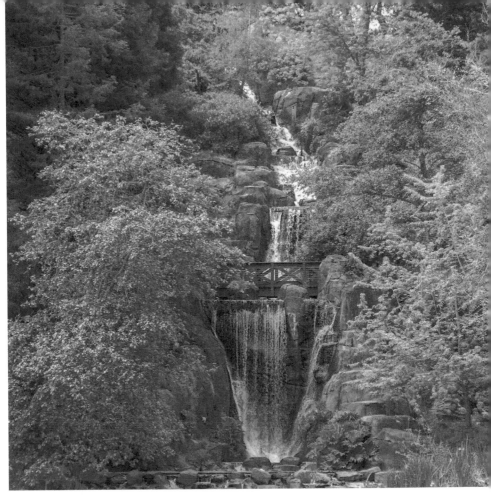

Huntington Falls is a photogenic man-made waterfall about 180 feet (50 m) north of the Pavilion. You can photograph the waterfall from across Stow Lake (above), and from bridges across the stream at the top, middle and bottom.

✉ **Addr:**	Golden Gate Park, San Francisco CA 94118	📍 **Where:**	37.768927 -122.472577
When:	Morning	👁 **Look:**	West
↔ **Far:**	120 m (400 feet)		

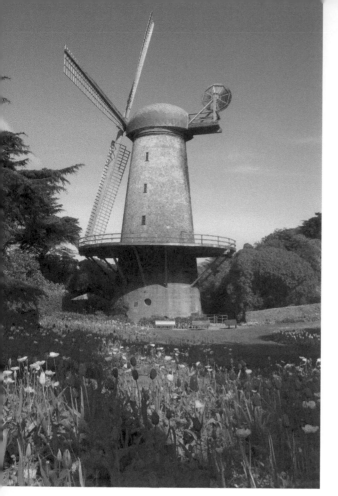

The **Dutch Windmill** is located in the northwest corner of the park. Standing 75 feet tall with 102 foot long sails, the windmill was built in 1903 to pump water draining to the ocean back into the park, to the reservoir that feeds Huntington Falls.

By the windmill is the Queen Wilhelmina Tulip Garden.

A second but less photogenic windmill, the Murphy Windmill, is located in the southwest corner of the park.

✉ **Addr:**	Ggp Access Rd, San Francisco CA 94121	♀ **Where:**	37.770208 -122.509101
❷ **What:**	Windmill	◑ **When:**	Morning
👁 **Look:**	Northwest	Ⓦ **Wik:**	Dutch_Windmill_(Golden_Gate_Park)

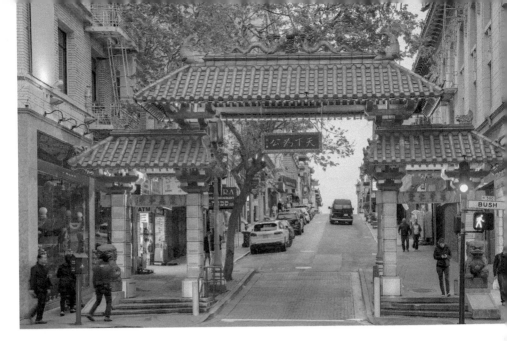

Chinatown in San Francisco is the oldest Chinatown in North America and the largest Chinese community outside Asia. Centered on Grant Avenue and Stockton Street, the neighborhood draws more visitors annually than the Golden Gate Bridge.

These were the first streets in San Francisco (then Yerba Buena). In 1835, the first house was built at, what is now, 823 Grant Avenue (opposite today's Peking Bazaar) and the original town square is now Portsmouth Square. California's first public school was erected in 1847 at the southwest corner of Portsmouth Square.

Above **Dragon's Gate** (also known as Chinatown Gate) is the grand entrance to Chinatown, at Grant Avenue and Bush Street.

Right: Dragons coil around lampposts at Grant Avenue and Sacramento Street.

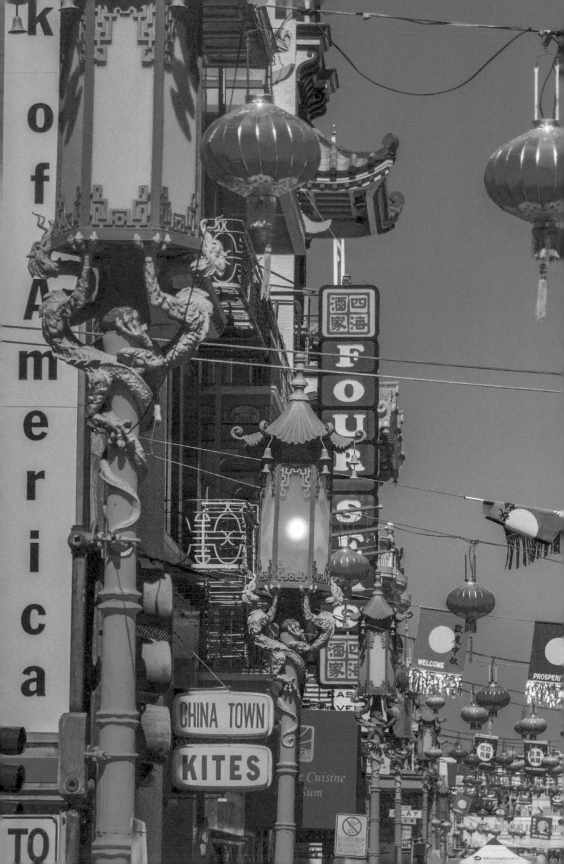

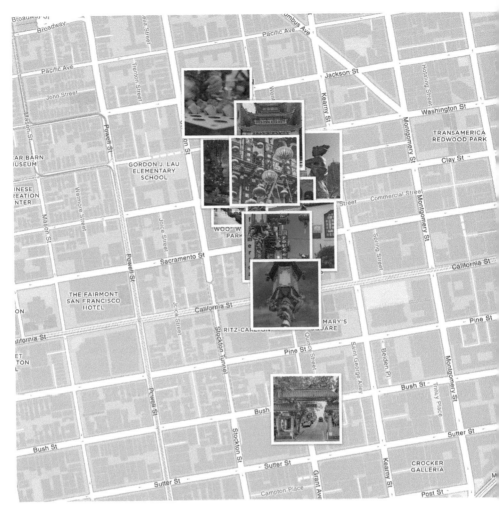

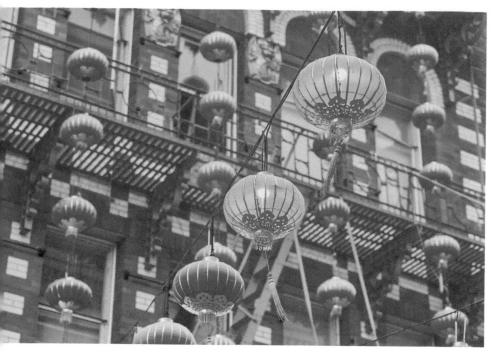

Above: Peking Bazaar is decorated with photogenic red lanterns, at 826 Grant Avenue. *Below:* Bruce Lee was born in Chinatown and the martial arts movie star is honored on Commercial Street at Grant.

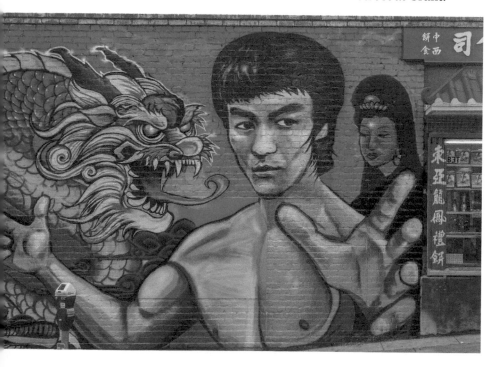

Above right: The Chinese Telephone Exchange was built in 1906 and remained in operation until 1949. *Below:* The Golden Gate Fortune Cookie Company is the only bakery where the cookies are still made by hand, the old-fashioned way. Entrance is free but taking photographs costs 50 cents. Located at 56 Ross Alley, the oldest alley in San Francisco, and used in the movie *Indiana Jones and the Temple of Doom.*

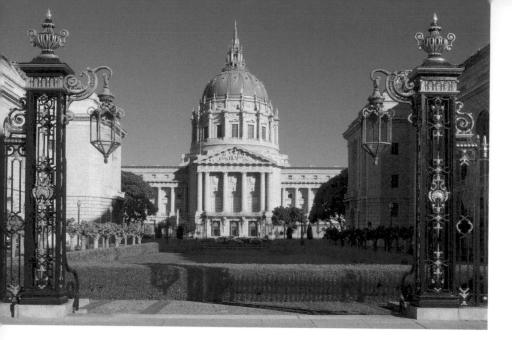

San Francisco City Hall is a Beaux-Arts monument to the City Beautiful movement that epitomized the high-minded American Renaissance of the 1880s.

The dome is the tallest in the U.S. — 42 feet higher than Washington DC's Capitol — and is based on the Baroque domes of Paris at Val-de-Grâce and Les Invalides.

City Hall can be fun to photograph at night when it is lit with over 220 color changeable LED light fixtures.

✉ **Addr:**	1 Goodlett Place, San Francisco CA 94102	♥ **Where:**	37.778953 -122.421459
❷ **What:**	City hall	☽ **When:**	Afternoon
👁 **Look:**	East	W **Wik:**	San_Francisco_City_Hall

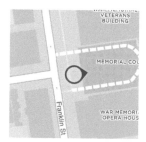

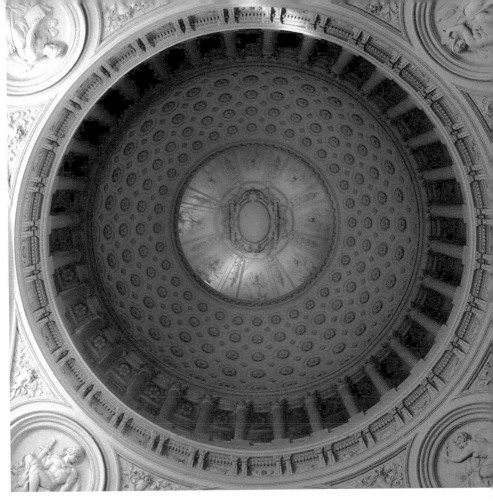

The **Rotunda** is the central, round atrium, with a towering dome and grand staircase. Marilyn Monroe and Joe DiMaggio were married here in 1954.

✉ **Addr:**	1 Goodlett Place, San Francisco CA 94102	♀ **Where:**	37.779280 -122.419248
❓ **What:**	Rotunda	◑ **When:**	Anytime
👁 **Look:**	Up	↔ **Far:**	0 m (0 feet)

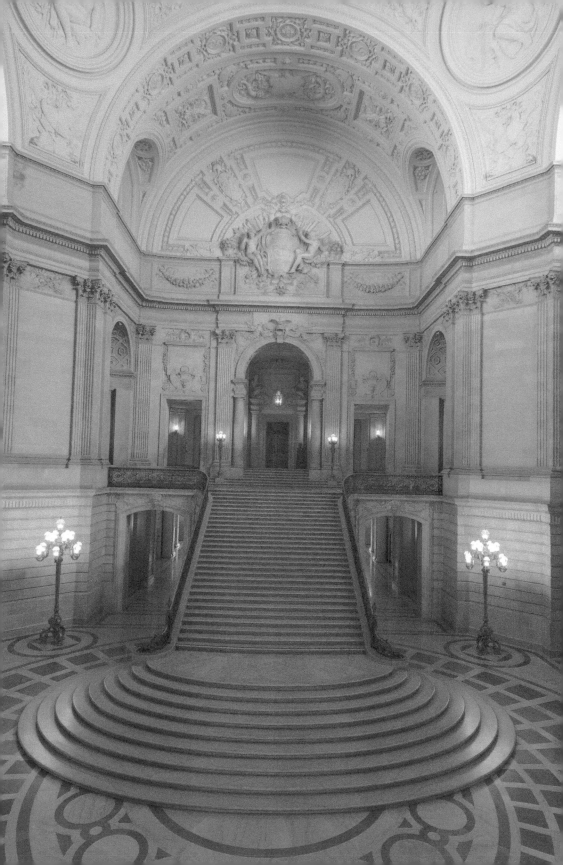

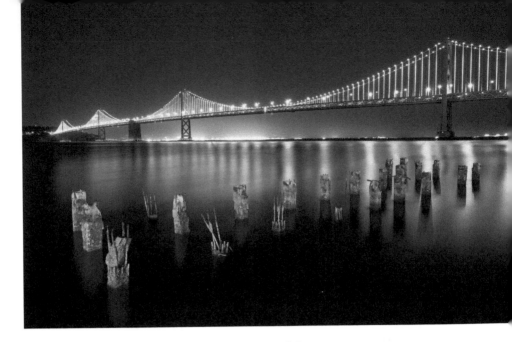

The **San Francisco–Oakland Bay Bridge**, known locally as the Bay Bridge, is a pair of bridges heading northeast. Pictured is the double-decked west bridge, opened in 1936, which connects through a tunnel in Yerba Buena Island to a two-lane bridge into Oakland.

This view is from the San Francisco Bay Trail on the Embarcadero at the foot of Howard Street, with the stubs of pier piles in the foreground.

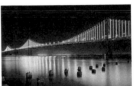

✉ **Addr:**	3-44 The Embarcadero, San Francisco CA 94105	♀ **Where:**	37.792802 -122.390996
◐ **When:**	Anytime	◉ **Look:**	East
W **Wik:**	San_Francisco%E2%80%93Oakland_Bay_Bridge		

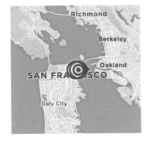

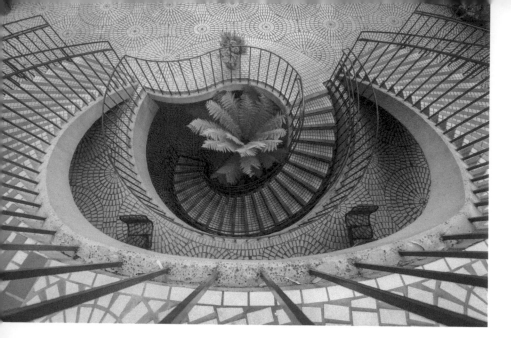

Embarcadero Center has two open-air spiral staircases which call your camera with curving, abstract lines and circular mosaic patterns. The staircases are at either end of the bridge between Two and Three Embarcadero.

Developed by John Portman, David Rockefeller and Trammell Crow, Embarcadero Center is a commercial complex of five office towers and two hotels, built between 1971 and 1989.

✉ **Addr:**	Three Embarcadero Center, San Francisco CA 94111	♀ **Where:**	37.794850 -122.397647
❷ **What:**	Spiral staircase	◑ **When:**	Afternoon
👁 **Look:**	Down	W **Wik:**	Embarcadero_Center

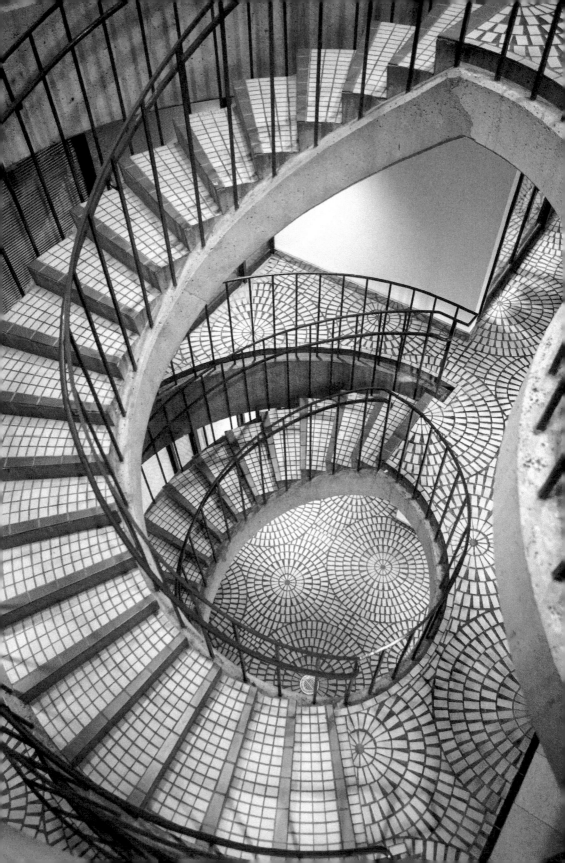

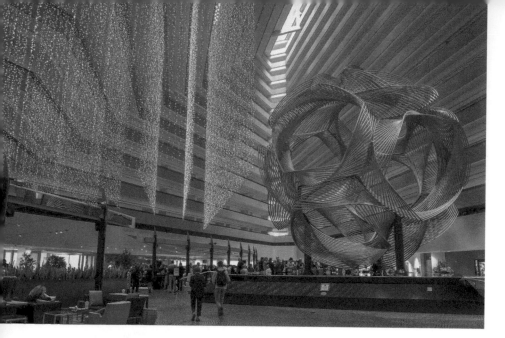

The **Hyatt Regency San Francisco** is part of the Embarcadero Center and has a soaring atrium. The 1973 design by John Portman holds the Guinness world record for the largest hotel lobby and was used in *The Towering Inferno* (1974) as the Glass Tower lobby.

The central artwork is called *Eclipse,* a 35-foot high geodesic sphere (1973, Charles Perry) built from pentagons using 1,400 of curved aluminum tubes.

✉ **Addr:**	Five Embarcadero Center, San Francisco CA 94111	♀ **Where:**	37.794116 -122.395889
❷ **What:**	Sculpture	◑ **When:**	Anytime
👁 **Look:**	North-northeast	W **Wik:**	Hyatt_Regency_San_Francisco

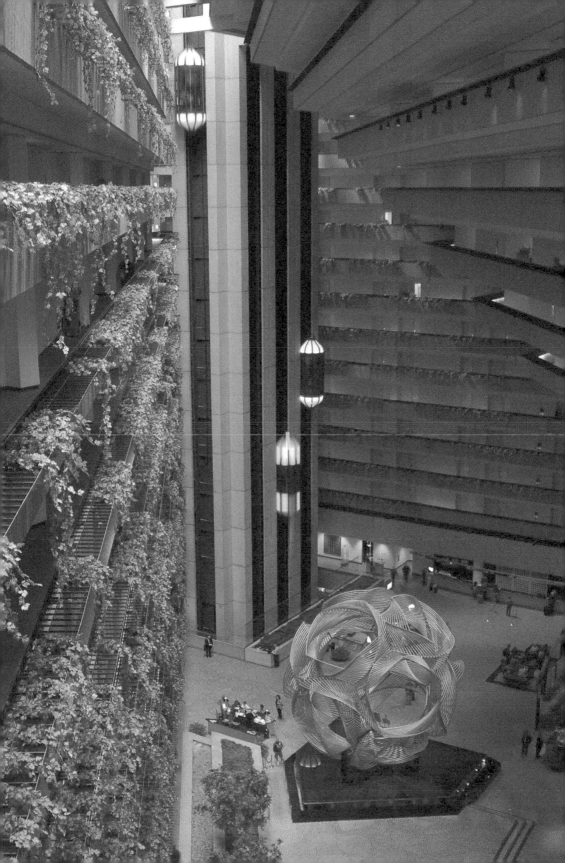

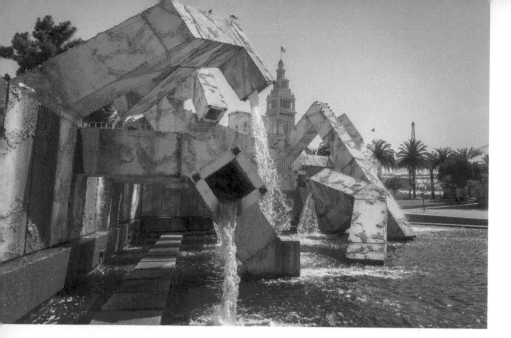

Vaillancourt Fountain is a large fountain at the Embarcadero Center's Justin Herman Plaza. The 1971 artwork by Armand Vaillancourt is controversial due to its stark, modernist appearance.

There are two bridges, or walk ways (with stairs), that allow the public to stand between the concrete tubes and have a view overlooking the plaza and city. A series of platforms at pool level permit pedestrian entry into the fountain and behind the falling water.

✉ **Addr:**	Justin Herman Plaza, San Francisco CA 94105	♀ **Where:**	37.795419 -122.395549
❓ **What:**	Fountain	⏾ **When:**	Afternoon
👁 **Look:**	East	Ⓦ **Wik:**	Vaillancourt_Fountain

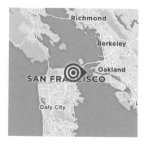
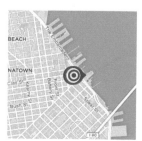
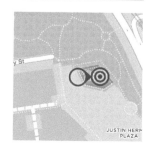

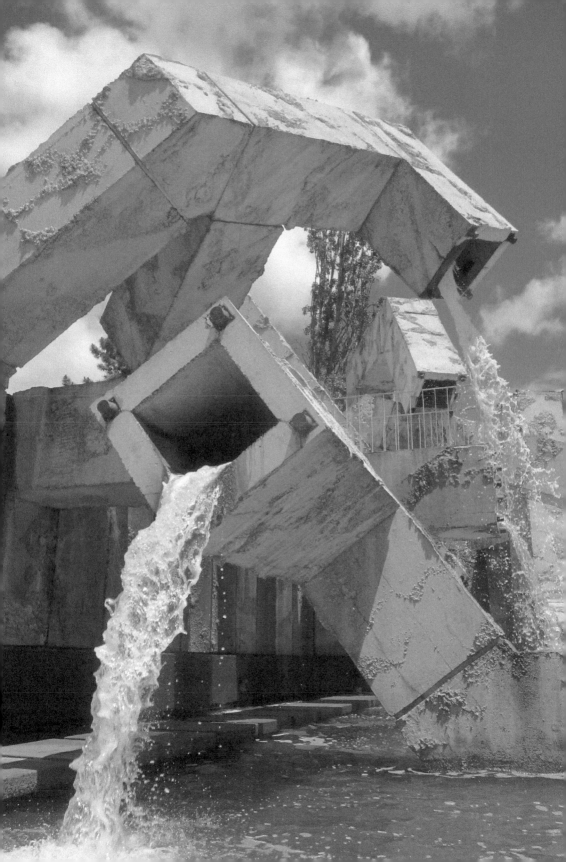

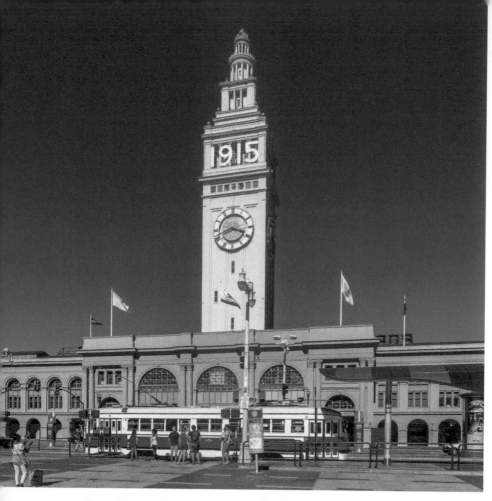

The **San Francisco Ferry Building** is a Beaux Arts landmark completed in 1898, with a 245-foot tall clock tower modeled after the 12th-century Giralda bell tower in Seville, Spain. During the 1930s, this was the world's second busiest transit terminal, after London's Charing Cross Station.

Inside on the second floor is a 660-foot-long (200 m) redeveloped room called the Great Nave.

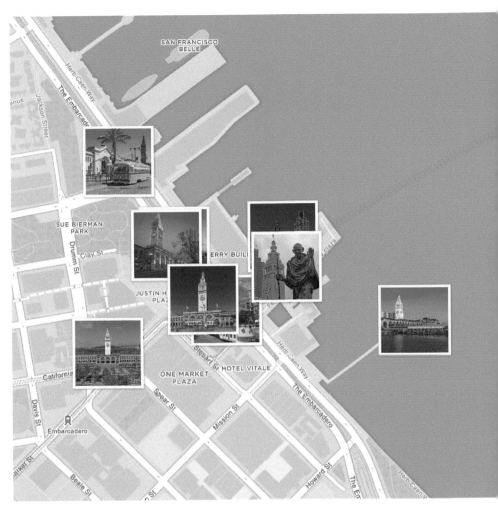

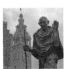

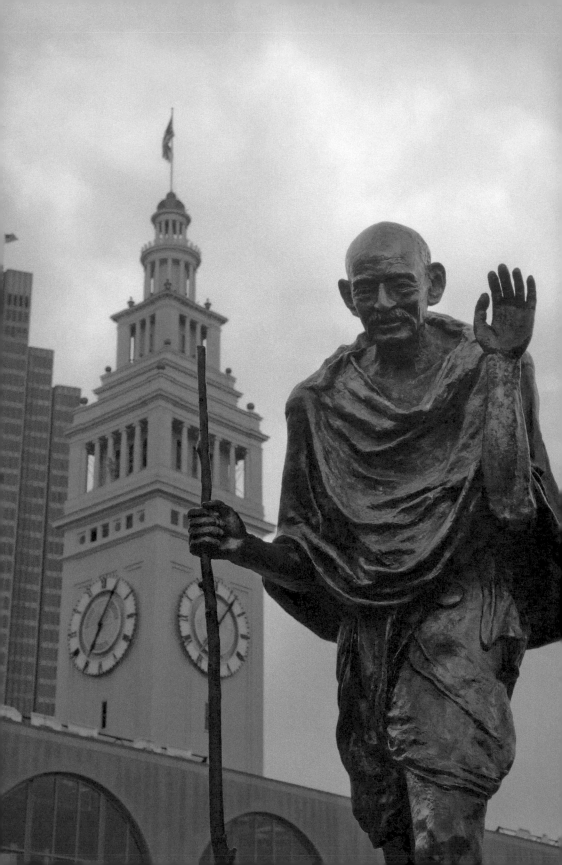

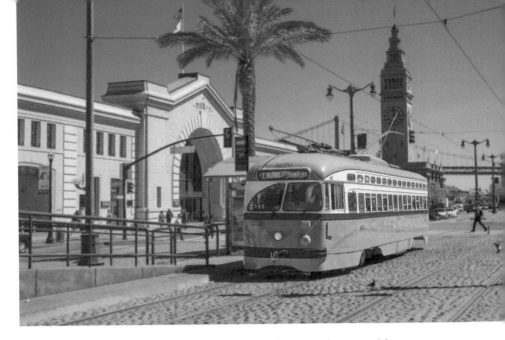

Left: **Gandhi** is a 1988 statue on the Ferry Plaza, on the east side (behind) the Ferry Building. *Above:* **The F Market and Wharves** heritage streetcar service runs past the Ferry Building, using mostly historic equipment from around the world. The trams run to Fisherman's Wharf and down Market Street. *Below:* Pier 14 has a view of the Ferry Building piers.

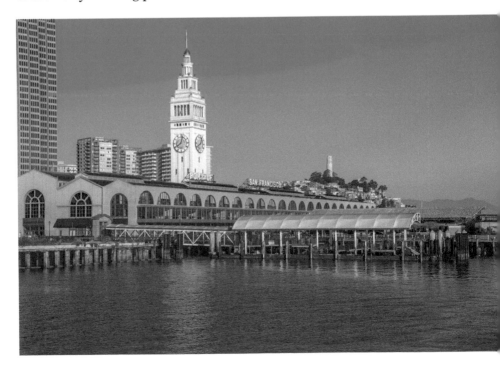

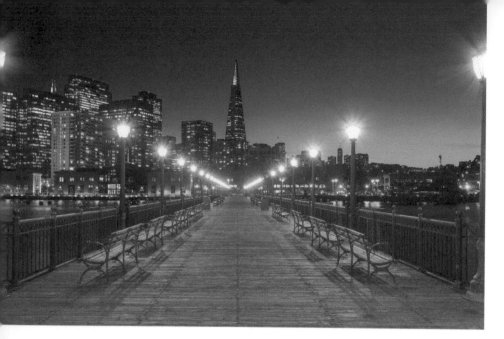

San Francisco skyline from Pier 7. This beautiful, wood-floored promenade has iron railings and street lamps, and a dusk view that leads to the Transamerica Pyramid.

✉ **Addr:**	Pier 7, San Francisco CA 94105	♀ **Where:**	37.800131 -122.394336
❓ **What:**	Skyline	⏱ **When:**	Anytime
👁 **Look:**	Southwest	↔ **Far:**	0.93 km (0.58 miles)

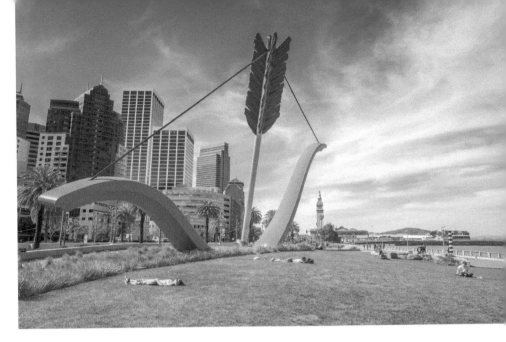

Cupid's Span is a giant sculpture of a bow and arrow, installed at Rincon Park in 2002. The artists Claes Oldenburg and Coosje van Bruggenthe were inspired by San Francisco's reputation as the home port of Eros, the Greek god of love, whose Roman namet was Cupid. Perhaps this is why Tony Bennett sang "I Left My Heart in San Francisco."

✉ **Addr:**	Embarcadero at Folsom, San Francisco CA 94117	♀ **Where:**	37.7910353 -122.3898138
❓ **What:**	Sculpture	◔ **When:**	Afternoon
👁 **Look:**	East-southeast	W **Wik:**	Embarcadero_(San_Francisco)

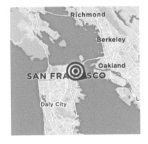
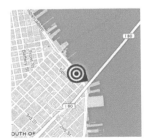
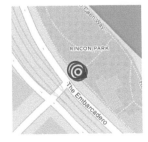

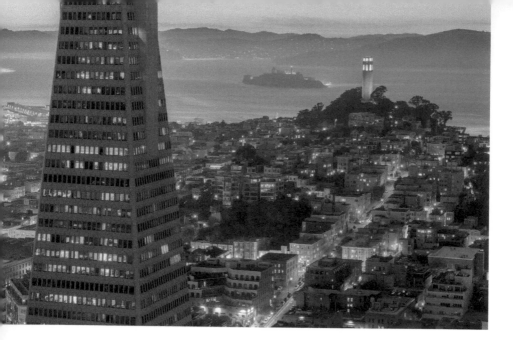

The **Loews Regency** hotel offers a view of three signature San Francisco locations in one shot — Transamerica Pyramid, Alcatraz and Coit Tower.

The 40th floor Sky Deck is San Francisco's highest outdoor venue, a bar and restaurant with this view north to Telegraph Hill and Marin. To the northwest, is a distant view of the Golden Gate Bridge.

✉ **Addr:**	222 Sansome St, San Francisco CA 94104	♀ **Where:**	37.7925 -122.4005
❓ **What:**	Rooftop bar	☾ **When:**	Anytime
👁 **Look:**	North-northwest	W **Wik:**	345_California_Center

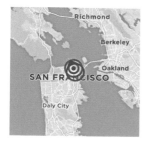
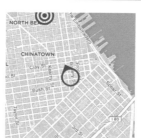

Columbus Tower, also known as the Sentinel Building, is a triangular copper-green bulding from 1907. Owned by director Francis Ford Coppola, this is the headquarters of the film studio he founded with George Lucas, American Zoetrope, producer of *American Graffiti*, *The Godfather Part II* and *Apocalypse Now*.

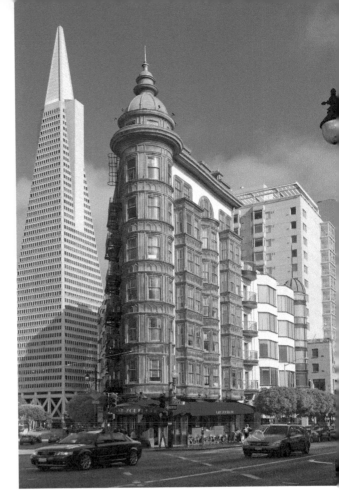

✉ **Addr:**	916 Kearny Street, San Francisco CA 94133	♀ **Where:**	37.796838 -122.405354
❓ **What:**	Building	◷ **When:**	Afternoon
👁 **Look:**	Southeast	W **Wik:**	Columbus_Tower_(San_Francisco)

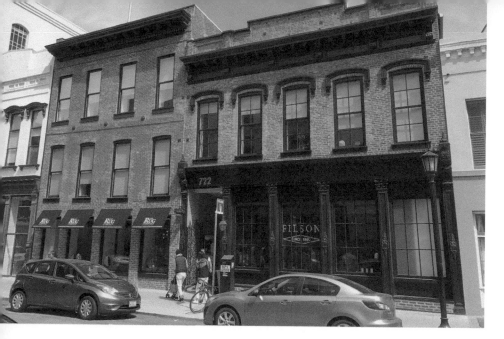

The **Jackson Square Historic District** features Gold Rush-era brick buildings by the original harbor, a shallow tidal cove east and southeast of here. Today's downtown is built on sand fill and at least 48 abandoned ships.

Above is the Belli Building, built in 1851 with interior columns thought to be ship's masts. To the far left (past the taller Genella Building, 1853) is the cream-colored Golden Era Building (1852). Home of the West Coast's first literary paper, poet and editor Bret Harte worked here. When Mark Twain moved to San Francisco in 1864, Harte edited and published Twain's first success, "The Celebrated Jumping Frog of Calaveras County" (1865).

✉ **Addr:**	722 Montgomery and Jackson, San Francisco CA 94111	♥ **Where:**	37.796038 -122.403471
❷ **What:**	Neighborhood thing	◑ **When:**	Afternoon
👁 **Look:**	East-northeast	W **Wik:**	Jackson_Square,_San_Francisco

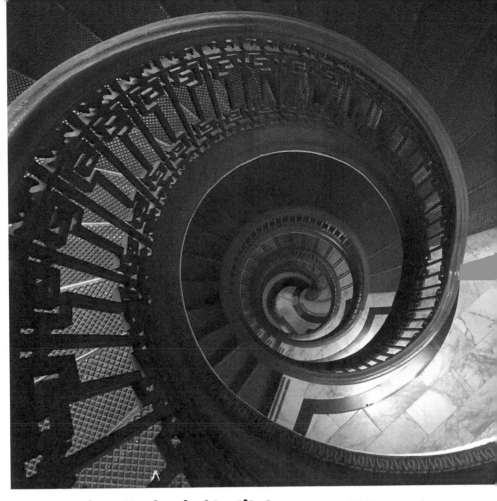

San Francisco Mechanics' Institute has a beautiful iron and marble spiral staircase from the lobby to the library. Designed in 1909 by Albert Pissis, this is the oldest library on the West Coast. Public tours tour on Wednesdays at noon.

✉ **Addr:**	57 Post St, San Francisco CA 94104	♀ **Where:**	37.788821 -122.402977
❷ What:	Spiral staircase	**◷ When:**	Anytime
👁 Look:	Down	**W Wik:**	San_Francisco_Mechanics%27_Institute

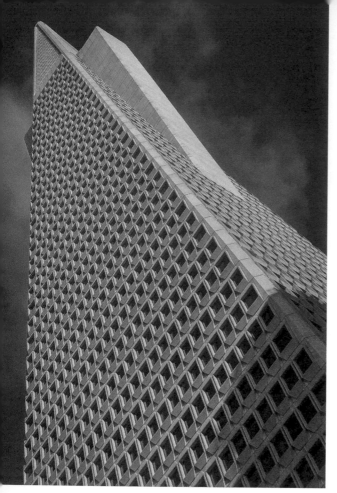

Transamerica Pyramid is the most iconic skyscraper in San Francisco. The 48-story futurist tapering tower was designed by William Pereira and completed in 1972. This was the tallest building in the city until 2017, when it was surpassed by Salesforce Tower.

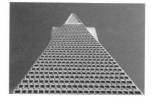

The Transamerica Corporation moved out of the building to Baltimore, MD but still depicts the building in its logo.

✉ **Addr:**	600 Montgomery Street, San Francisco CA 94111	♀ **Where:**	37.794697 -122.402681
❓ **What:**	Pyramid	◑ **When:**	Morning
👁 **Look:**	North	W **Wik:**	Transamerica_Pyramid

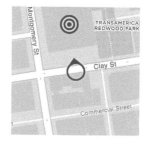

Montgomery Street Steps has a view down Montgomery Street of the Transamerica Pyramid. Another nice view is from a block south, at Vallejo Street.

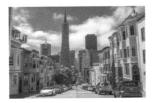

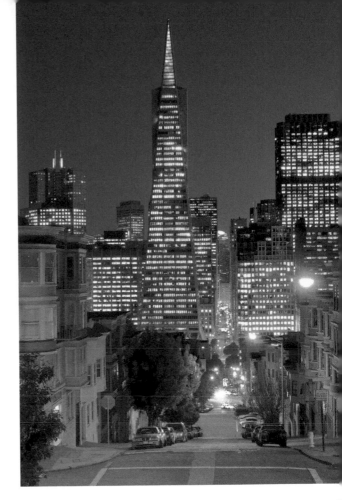

✉ **Addr:**	1250 Montgomery Street, San Francisco CA 94133	♀ **Where:**	37.800407 -122.404323	
◑ **When:**	Anytime	◉ **Look:**	South-southeast	
↔ **Far:**	0.60 km (0.37 miles)			

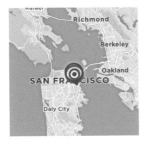

Puddle Jumpers is a sculpture at the base of the Transamerica Pyramid in a small private park to the east called Transamerica Redwood Park. A number of redwood trees were transplanted from the local area to this park when the tower was built.

The sculpture is by Glenna Goodacre, 1989, and faces a pond with bronze frogs jumping on lily leaves, called Frog Fountain by Anthony Guzzardo. The ensemble honors Mark Twain, who lived and worked nearby when he wrote "The Celebrated Jumping Frog of Calaveras County", 1865.

✉ **Addr:**	600 Montgomery St, San Francisco CA 94111	♀ **Where:**	37.79508 -122.402223
❓ What:	Sculpture	**◐ When:**	Afternoon
👁 Look:	Northeast	**↔ Far:**	9 m (30 feet)

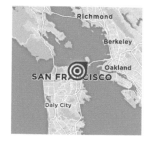
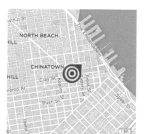
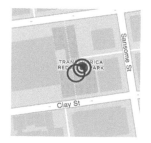

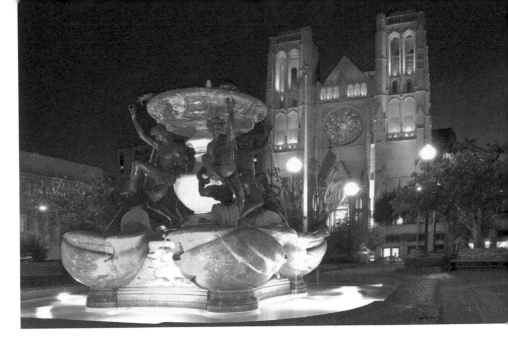

Fountain of the Turtles is a copy of *Fontana della Tartarugh* in Rome by Giacomo Della Porta and Taddeo Landini in 1583. The fountain anchors Huntington Park in Nob Hill, and provides a good foreground to Grace Cathedral.

The cathedral is famed for its two labyrinths, varied stained glass windows, the Keith Haring AIDS Chapel altarpiece, and its forty-four bell carillon.

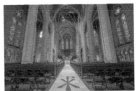

✉ **Addr:**	Huntington Park, San Francisco CA 94108	♥ **Where:**	37.792193 -122.412082
❷ **What:**	Sculpture	◑ **When:**	Anytime
👁 **Look:**	West-southwest	↔ **Far:**	6 m (20 feet)

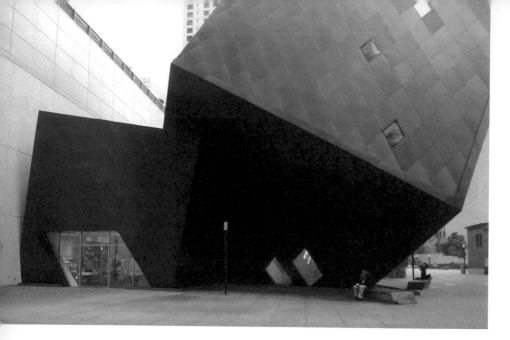

Contemporary Jewish Museum (CJM) has a deconstructivist 2008 addition by Daniel Libeskind with a dark-blue stainless steel tilted cube.

The main building is an historic electric substation from 1881, with classical revival additions by Willis Polk in 1905-09.

✉ **Addr:**	736 Mission Street, San Francisco CA 94103	♥ **Where:**	37.785541 -122.403960
❷ **What:**	Museum	◑ **When:**	Afternoon
◉ **Look:**	North	W **Wik:**	Contemporary_Jewish_Museum#Architecture

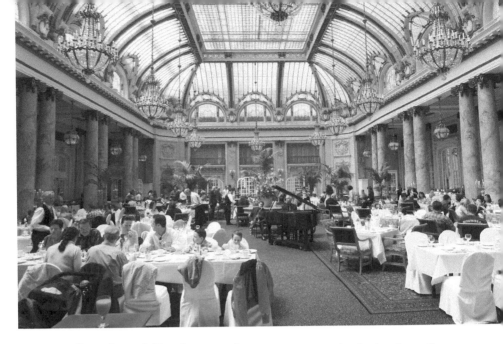

The **Garden Court Restaurant**, also known as the "Palm Court" in the Palace Hotel, has been one of San Francisco's most prestigious hotel dining rooms since the day it opened in 1909.

The glass-domed restaurant starred in the finale of the 1997 David Fincher film *The Game* with Michael Douglas.

✉ **Addr:**	2 New Montgomery St, San Francisco CA 94105	♀ **Where:**	37.788027 -122.401659
❓ **What:**	Skylight	◑ **When:**	Anytime
👁 **Look:**	West-southwest	Ⓦ **Wik:**	Palace_Hotel,_San_Francisco

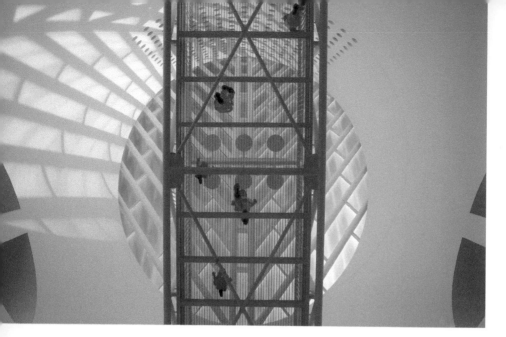

SFMOMA (The San Francisco Museum of Modern Art) was the first museum on the West Coast devoted solely to 20th-century art and is one of the largest in the world for modern and contemporary art.

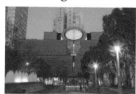

The original 1995 Mario Botta-designed building consists of galleries rising around a central, skylighted atrium, with a rooftop garden opened in 2009. An extension in 2016 by Norwegian architecture firm Snøhetta evokes the city's famous fog wall rolling in over rippling Bay waters, with undulating white panels.

✉ **Addr:**	151 3rd St, San Francisco CA 94103	♀ **Where:**	37.78547 -122.401326
❓ **What:**	Museum	◐ **When:**	Afternoon
👁 **Look:**	Northeast	W **Wik:**	San_Francisco_Museum_of_Modern_Art

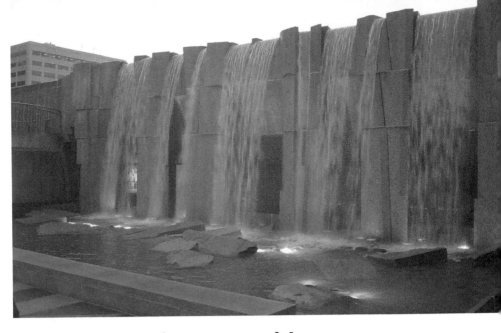

The **Martin Luther King, Jr. Memorial** includes a waterfall (the largest fountain on the West Coast) over etched glass excerpts of King's speeches. The 1993 memorial was a collaborative project between Sculptor Houston Conwill, Poet Estella Majoza and Architect Joseph de Pace.

Conwill said the act of entering the Fountain, reading the text beneath the water, then exiting back out into the garden, represents "a cultural pilgrimage and contemplative metaphorical journey of transformation," similar to the Southern tradition of baptism by full immersion in water common within Old School Baptist churches like those of King's grandfather.

"Let justice roll down like waters and righteousness like a mighty stream." — Martin Luther King Jr., Letter from the Birmingham Jail.

✉ **Addr:**	Yerba Buena Gardens, San Francisco CA 94103	⚲ **Where:**	37.784472 -122.402427
❷ **What:**	Fountain	◑ **When:**	Afternoon
👁 **Look:**	Northeast	↔ **Far:**	18 m (59 feet)

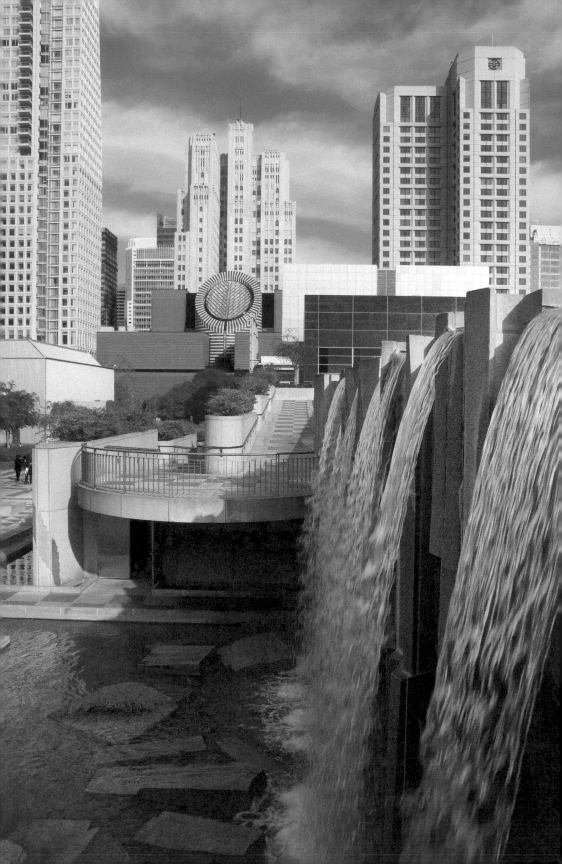

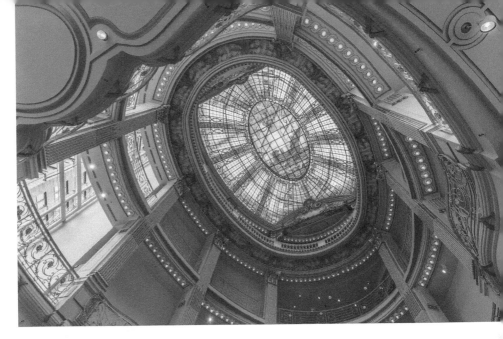

City of Paris Skylight is an oval, Beaux-Arts stained glass dome skylight dating from 1909 from the City of Paris Dry Goods Company. One of San Francisco's most important department stores from 1850 to 1976, now redeveloped as Neiman Marcus, Union Square.

During the 1849 California Gold Rush, brothers Felix and Emile Verdier chartered a ship, the *Ville de Paris* (City of Paris) to sail from France loaded with silks, laces, fine wines, champagne, and Cognac. Upon arrival in San Francisco, all the goods were bought without even unloading, often with bags of gold dust. Emile Verdier quickly returned to France and loaded the ship bound for San Francisco arriving in 1851, where he opened a store called the City of Paris.

✉ **Addr:**	150 Stockton Street, San Francisco CA 94108	♀ **Where:**	37.787425 -122.406349
❷ **What:**	Skylight	⏱ **When:**	Anytime
👁 **Look:**	North	W **Wik:**	City_of_Paris_Dry_Goods_Co.

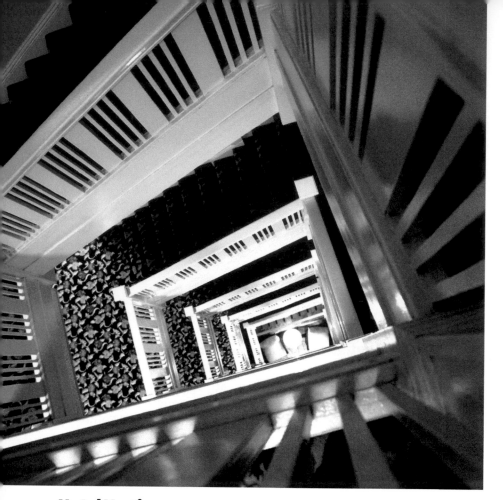

Hotel Vertigo features the staircase used in Alfred Hitchcock's 1958 film "Vertigo."

✉ **Addr:**	940 Sutter St, San Francisco CA 94109	♀ **Where:**	37.788573 -122.415923
❷ **What:**	Staircase	◑ **When:**	Anytime
◉ **Look:**	North	↔ **Far:**	0 m (0 feet)

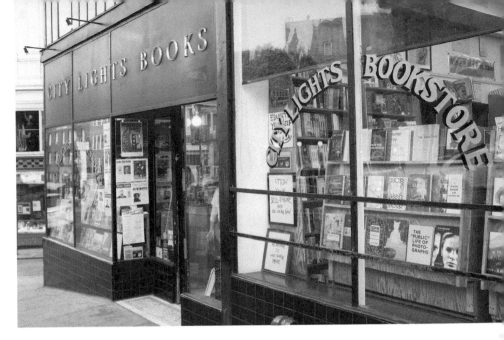

City Lights Bookstore is an independent bookstore-publisher founded in 1953, renowned for publishing Allen Ginsberg's "Howl and Other Poems" in 1956.

At the adjacent alley, you can join the famed beat author Jack Kerouac, or at least his name.

⊠ **Addr:**	261 Columbus Ave, San Francisco CA 94133	♀ **Where:**	37.79754 -122.406331
❷ **What:**	Bookstore	☽ **When:**	Morning
👁 **Look:**	West-northwest	W **Wik:**	City_Lights_Bookstore

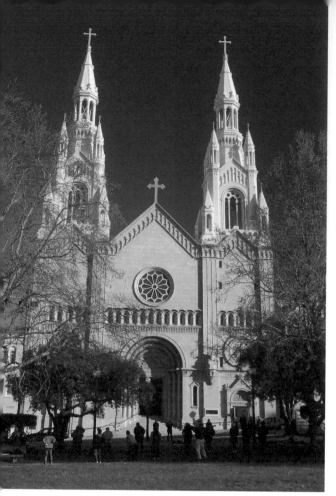

Saints Peter and Paul Church is a

Roman Catholic Church on Washington Square.

The church is prominently featured in the Clint Eastwood movies Dirty Harry and The Dead Pool. After their civil ceremony in 1954, Marilyn Monroe and Joe DiMaggio returned for photographs on the steps of this church.

✉ **Addr:**	666 Filbert St, San Francisco CA 94133	♦ **Where:**	37.800665 -122.410078
❓ **What:**	Church	◑ **When:**	Morning
👁 **Look:**	North	Ⓦ **Wik:**	Saints_Peter_and_Paul_Church,_San_Francisco

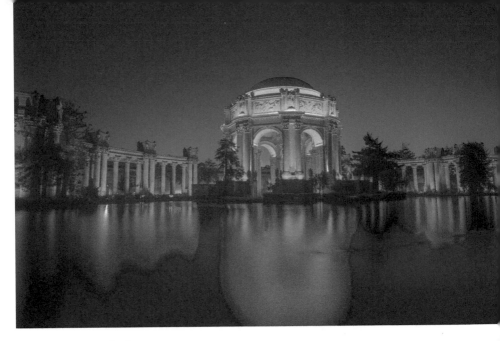

The **Palace of Fine Arts** is a romantic and photogenic monumental structure originally constructed for the 1915 Panama-Pacific Exposition. Bernard Maybeck Roman Classical rotunda with Corinthian columns and flanking colonnades. Rebuilt in 1965, the Palace is popular for wedding party photographs.

Intended as a fictional ruin from another time, the structure was designed by Bernard Maybeck based on Roman and Ancient Greek architecture. Built around a small artificial lagoon, the Palace of Fine Arts is composed of a wide, 1,100 ft (340 m) pergola around a central rotunda situated by the water. The lagoon was intended to echo those found in classical settings in Europe, where the expanse of water provides a mirror surface to reflect the grand buildings and an undisturbed vista to appreciate them from a distance.

✉ **Addr:**	3301 Lyon St, San Francisco CA 94123	📍 **Where:**	37.802485 -122.447079
❓ **What:**	Monumental structure	☽ **When:**	Morning
👁 **Look:**	West-northwest	W **Wik:**	Palace_of_Fine_Arts

 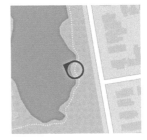

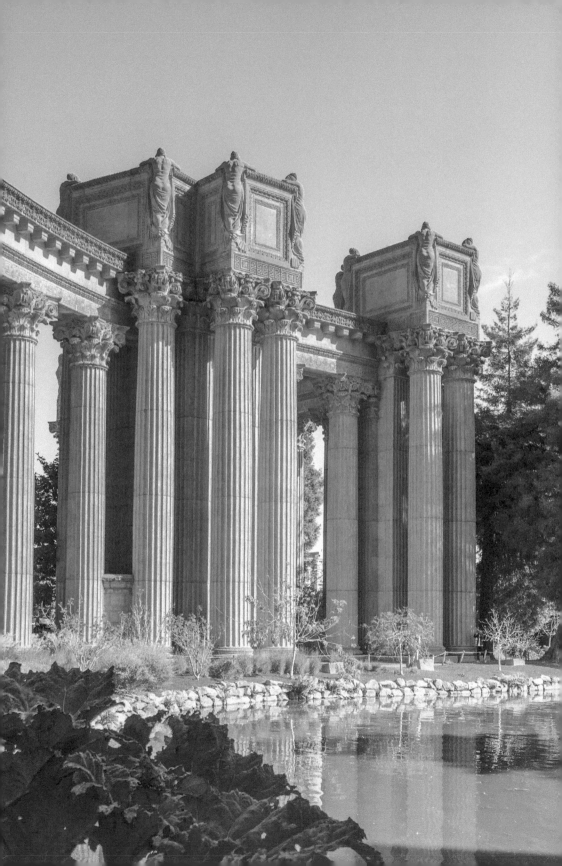

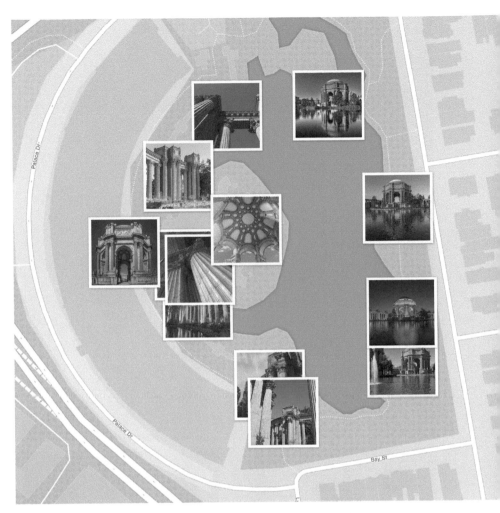

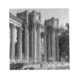

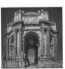

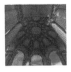

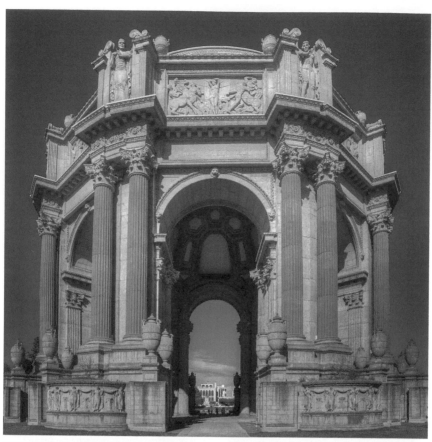

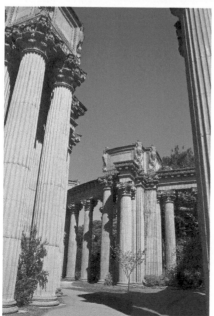

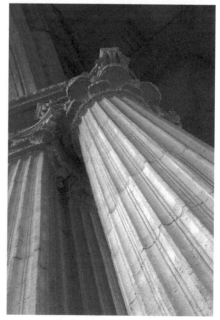

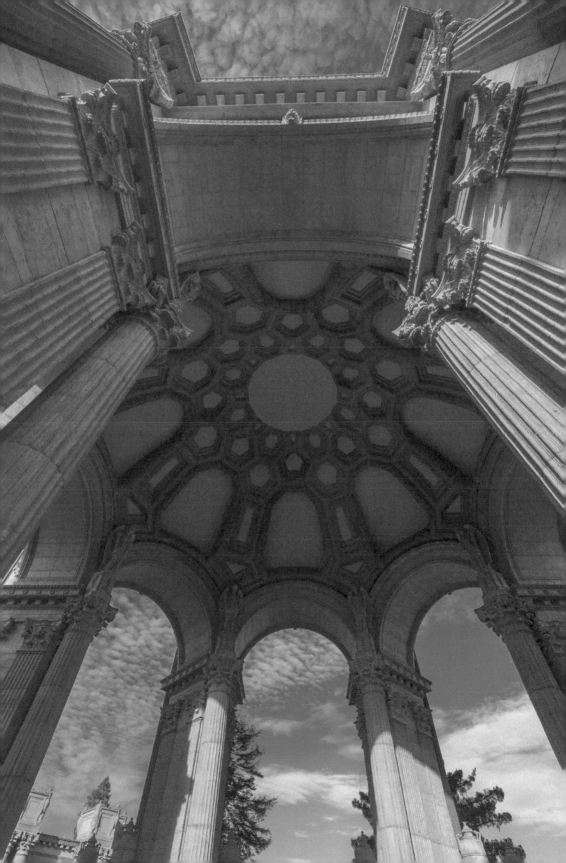

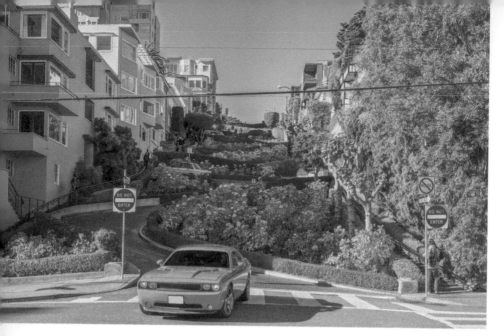

Lombard Street is famous as for a steep, one-block section with eight hairpin turns known as "the crookedest street in the world." Hydrangeas, hairpins and hardbricks poses for your camera.

The Powell-Hyde cable car stops at the top of the block on Hyde Street on Russian Hill. From here you can see Coit Tower on Telegraph Hill and the Bay Bridge, while looking down the crooked street to Leavenworth Street.

The design, first suggested by property owner Carl Henry and built in 1922, was intended to reduce the hill's natural 27 percent grade, which was too steep for most vehicles. The crooked block is around 600 feet (180 m) long, paved with red bricks.

✉ **Addr:**	1000 Lombard St, San Francisco CA 94133	♀ **Where:**	37.802201 -122.417908
❓ **What:**	Street thing	🕐 **When:**	Morning
👁 **Look:**	West	W **Wik:**	Lombard_Street_(San_Francisco)

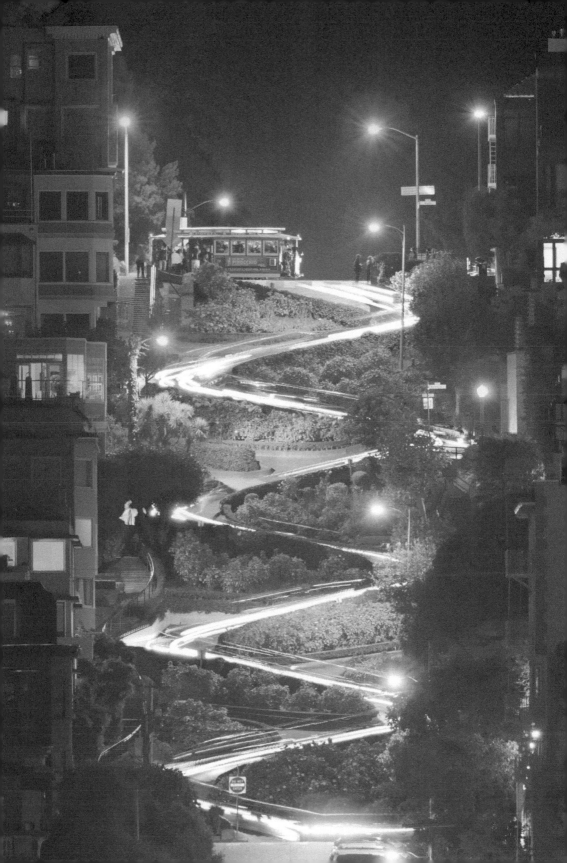

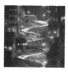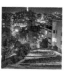

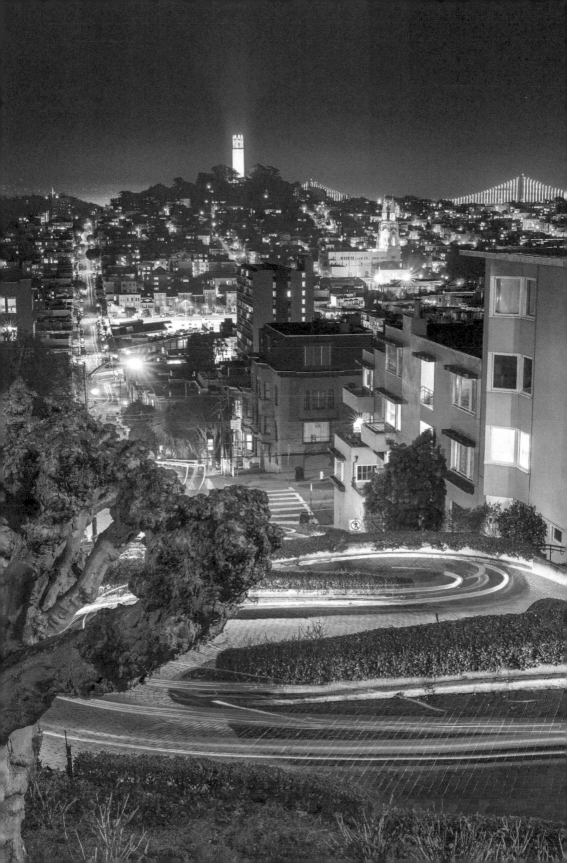

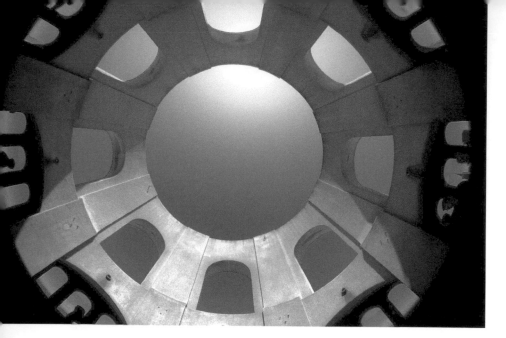

Coit Tower is a 210-foot (64 m) Art Deco tower built in 1933 on Telegraph Hill. There is an observation deck at the top (above) [paid admission] with a 360° view of San Francisco, including the Transamerica Pyramid, Downtown, Fisherman"s Wharf and Lombard Street.

At the plaza is a statue of Christopher Columbus.

Coit Tower was paid for with money left by Lillie Hitchcock Coit (1843-1929), a wealthy socialite who loved to chase fires in the early days of the city's history. The Tower is dedicated to the volunteer firemen who had died in San Francisco's five major fires.

✉ **Addr:**	1 Telegraph Hill Blvd, San Francisco CA 94133	⚲ **Where:**	37.803005 -122.406138
❓ **What:**	Tower	⏾ **When:**	Morning
👁 **Look:**	South	W **Wik:**	Coit_Tower

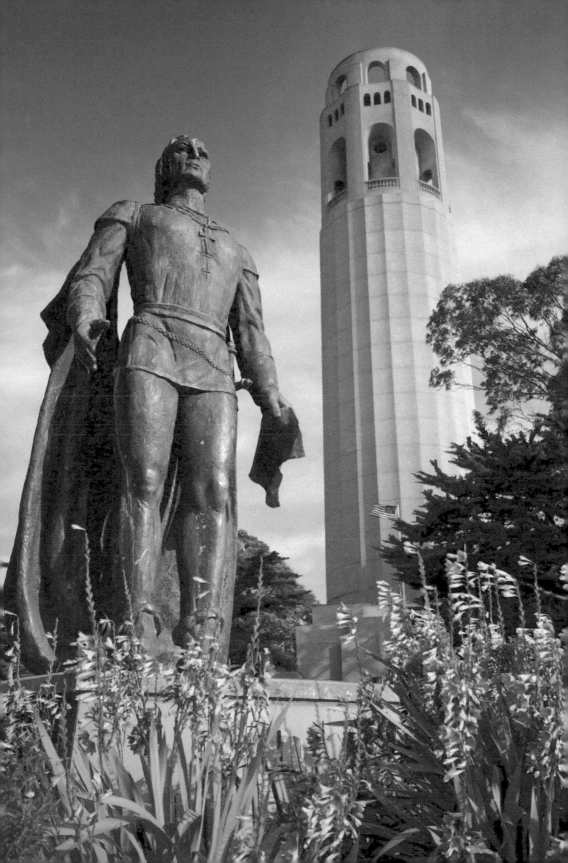

Rainbow Crosswalks are four pedestrian crossings at the center of The Castro district, one of the first gay neighborhoods in the United States. Located at Castro and 18th streets, the crosswalks were installed in 2014 to show LGBT pride. They were inspired by crosswalks in L.A.'s West Hollywood neighborhood.

Nearby is Harvey Milk's former camera shop, Castro Camera (at 575 Castro Street). An avid photographer, Milk opened the store in 1972 and became California's first openly gay elected official in 1977. He was assassinated the following year.

✉ **Addr:**	500 Castro Street at 18th, San Francisco CA 94114	📍 **Where:**	37.760858 -122.434956
❓ **What:**	Pedestrian crossing	🕐 **When:**	Morning
👁 **Look:**	West-southwest	↔ **Far:**	16 m (52 feet)

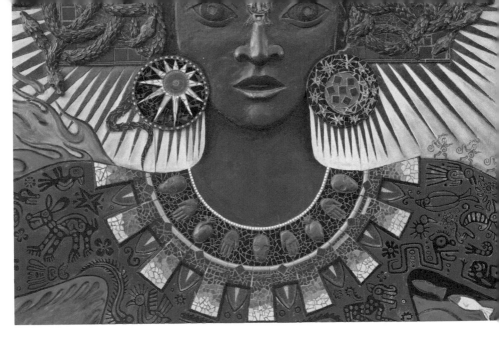

Tonantzin Renace is a mural of the mother of the Aztec gods. The artist, Colette Crutcher, made the mural in 1998 for the Instituto Pro Musica, an organization dedicated to the performance of music old and new from Spain and Latin America, where she sings in the choral group.

The mural is on a wall along 16th Street, east of Sanchez Street, in The Castro neighborhood.

✉ **Addr:**	3499-3471 16th St, San Francisco CA 94114	♀ **Where:**	37.764410 -122.430522
❓ **What:**	Mural	⏱ **When:**	Morning
👁 **Look:**	North	W **Wik:**	Tonantzin

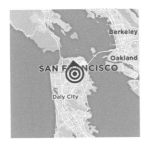
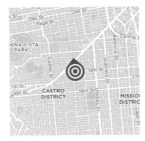

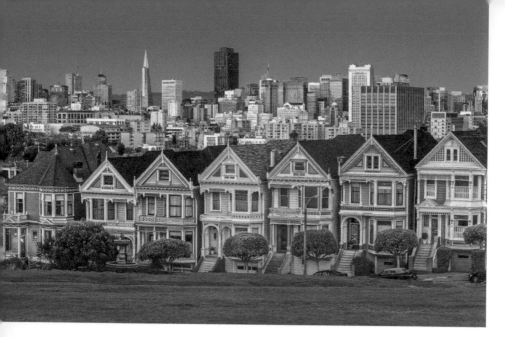

Postcard Row at Alamo Square is a set of seven Painted Ladies (colorful Victorian houses) along Alamo Square Park with the San Francisco skyline as a backdrop. These Seven Sisters adorn many postcards, and the opening credits to TV's "Full House."

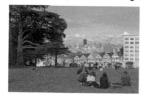

Alamo Hill was named after the lone cottonwood tree ("alamo" in Spanish) by a watering hole on the horseback trail from Mission Dolores to the Presidio in the 1800s. Today, the Alamo Square area and the Pacific Heights neighborhood contain the largest concentration of Victorian houses (and large houses) in San Francisco.

✉ **Addr:**	710-720 Steiner Street, San Francisco CA 94117	♀ **Where:**	37.7757981 -122.4337596
❓ **What:**	Houses	☽ **When:**	Afternoon
👁 **Look:**	East-northeast	W **Wik:**	Alamo_Square,_San_Francisco

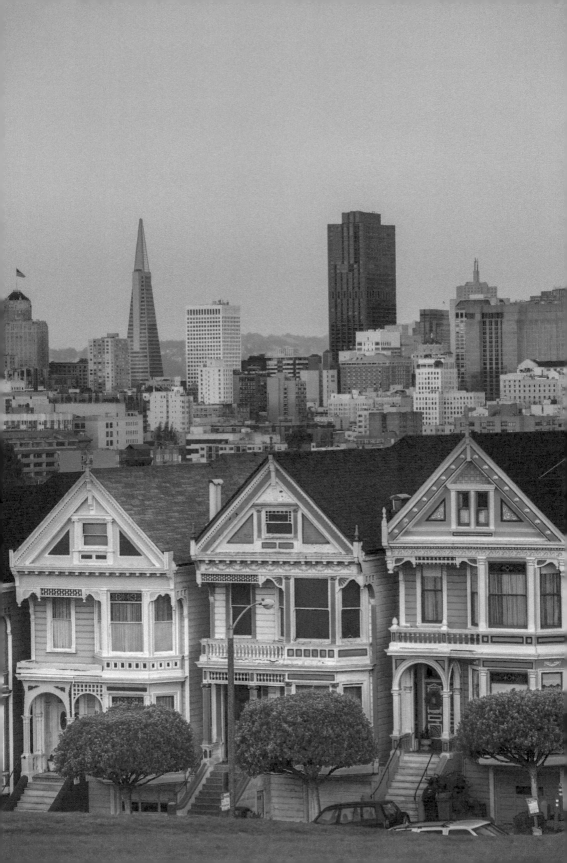

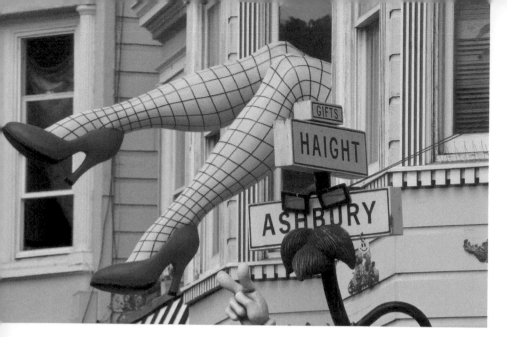

Piedmont Boutique has a come-hither pair of boudoir legs kicking from a window. Designed by local artist Barry Forman, the legs are above an "outfitter of disco divas and drag queens" in Haight-Ashbury.

The 1906s hippie movement sprung up in Haight-Ashbury, becoming home to The Summer of Love (1967). The first ever head shop, Ron and Jay Thelin's Psychedelic Shop, opened on Haight Street on January 3, 1966, offering hippies a spot to purchase marijuana and LSD. The members of Jefferson Airplane, the Grateful Dead, and Janis Joplin, all lived close to the intersection.

✉ **Addr:**	1452 Haight St, San Francisco CA 94117	♀ **Where:**	37.770148 -122.446049
❷ **What:**	Sculpture	◑ **When:**	Morning
👁 **Look:**	West-northwest	↔ **Far:**	16 m (52 feet)

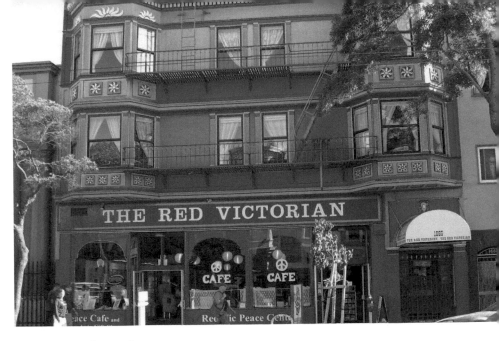

The Red Victorian is a historic hotel built in 1904 in Haight-Ashbury. Originally named the Jefferson Hotel, which is rumored to have been a brothel, the building was painted and renamed in 1977 by Sami Sunchild who hosted World Peace Conversations here every Sunday morning.

Sunchild's hotel was also known for the themed, unique guest room designs such as the "Summer of Love" room, the "Flower Children" room, and the "Peacock" room with eclectic, themed decor.

✉ **Addr:**	1665 Haight St, San Francisco CA 94117	♀ **Where:**	37.769563 -122.450232
❓ **What:**	House	⏲ **When:**	Afternoon
👁 **Look:**	South-southeast	W **Wik:**	The_Red_Victorian

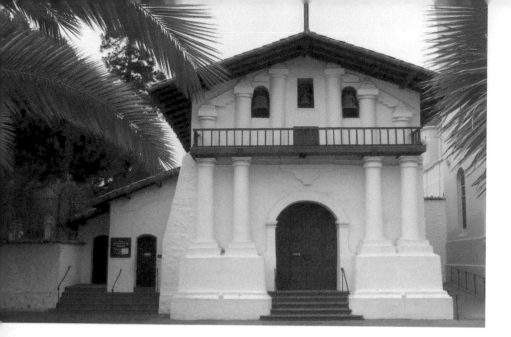

Mission San Francisco de Asís is the oldest surviving structure in San Francisco and the sixth religious settlement established as part of the California chain of missions.

The original adobe mission structure is the smaller building at left, while the larger structure is a basilica completed in 1918, based on the 1915 California Building in San Diego's Balboa Park.

✉ **Addr:**	320 Dolores Street, San Francisco CA 94114	♀ **Where:**	37.764206 -122.426438
❷ **What:**	Mission	◑ **When:**	Morning
👁 **Look:**	West	W **Wik:**	Mission_San_Francisco_de_Asís

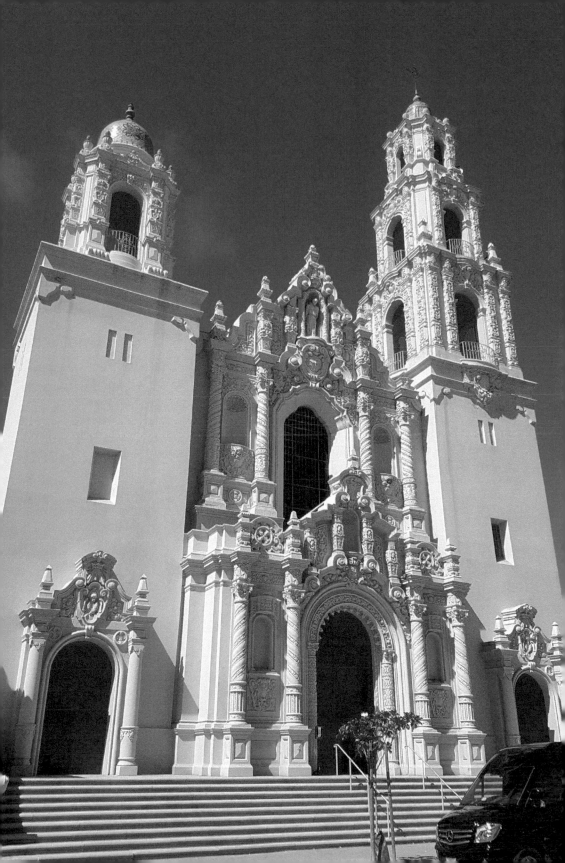

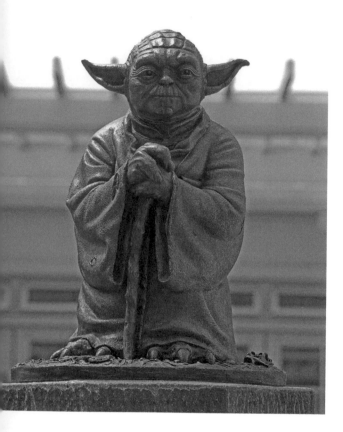

Lucasfilm Headquarters

displays Star Wars props and costumes. An original Darth Vader costume and an R2-D2 are in the lobby of Building B, open to the public during regular business hours.

Outside on the patio is a fountain with a "life"-size sculpture of Jedi Master Yoda. Remember, "Do, or do not, there is no try."

A Spanish fort in 1776, the Presidio is now a park, part of the Golden Gate National Recreation Area. In 1999, George Lucas won the rights to redevelop the old Army Hospital into office space for Lucasfilm and Industrial Light & Magic.

✉ **Addr:**	1 Letterman Dr Building B, San Francisco CA 94129	♀ **Where:**	37.798773 -122.450371
❓ **What:**	Building	◑ **When:**	Morning
👁 **Look:**	West-northwest	Ⓦ **Wik:**	Lucasfilm

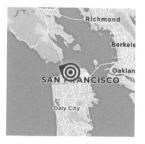
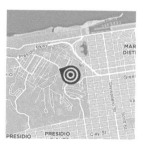

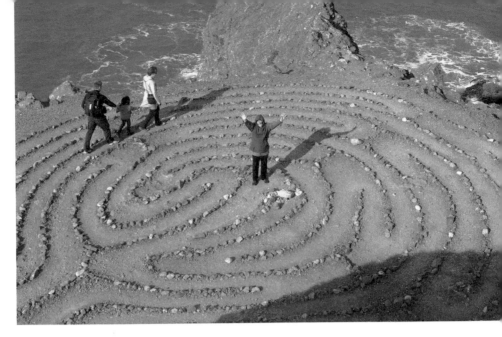

Lands End Labyrinth at Eagle Point is a hidden maze of stones created in 2004 by local artist Eduardo Aguilera.

✉ **Addr:**	Lands End, San Francisco CA 94121	♀ **Where:**	37.7878881 -122.5057562
❷ **What:**	Labyrinth	☽ **When:**	Morning
👁 **Look:**	Northwest	W **Wik:**	Lands_End_(San_Francisco)

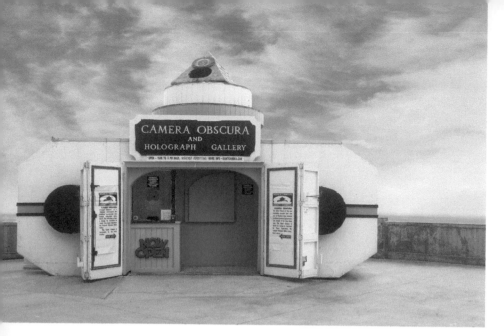

Camera Obscura is a giant camera, showing the surroundings via an ancient technique. Light enters the building via an angled mirror in the metal hood, passes through a lens with a 150 in. (381 cm) focal length and is projected onto a horizontal parabolic white "table" in a black room.

The camera was installed in 1946 and modified in 1957 to look like a large instant camera. It lies behind the Cliff House, a restaurant at Lands End.

✉ **Addr:**	1096 Point Lobos Ave, San Francisco CA 94121	♀ **Where:**	37.778382 -122.514165	
❷ **What:**	Exhibit	◐ **When:**	Morning	
👁 **Look:**	South-southwest	W **Wik:**	Camera_Obscura_(San_Francisco,_California)	

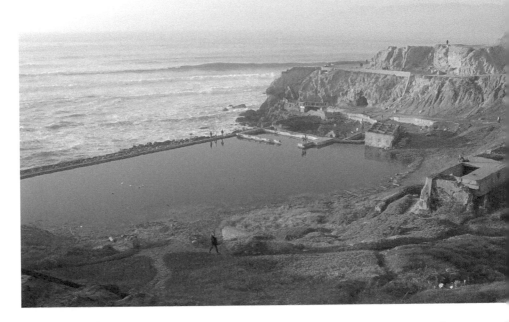

Sutro Baths is the ruins of a burned and abandoned swimming pool complex.

Visible in this photo (as a black arch in the center-top-right) is a cave, actually a man-made tunnel, 200-foot-long (60 m) under the headland. The entrance is at 37.780775,-122.5140667.

✉ **Addr:**	Point Lobos Ave, San Francisco CA 94121	♀ **Where:**	37.779532 -122.513209
❷ **What:**	Ruins	☀ **When:**	Morning
👁 **Look:**	Northwest	W **Wik:**	Sutro_Baths

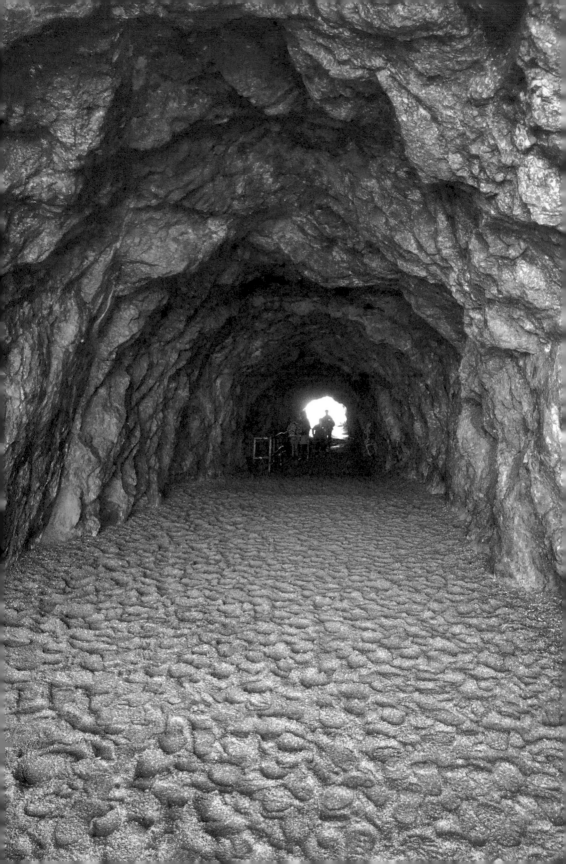

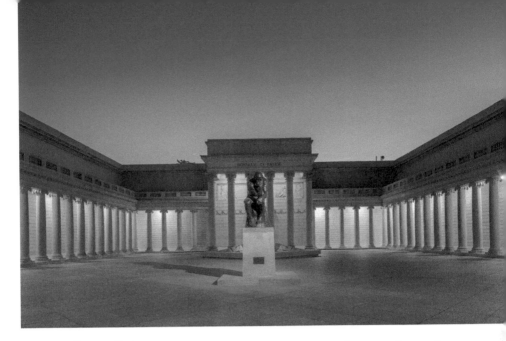

The **Legion of Honor** (formerly known as The California Palace of the Legion of Honor) is a fine arts museum in Lincoln Park. The building is a full-scale replica of the French Pavilion at the 1915 Panama–Pacific International Exposition, which in turn was a three-quarter-scale version of the Palais de la Légion d'Honneur in Paris, by Pierre Rousseau (1782).

✉ **Addr:**	100 34th Avenue, San Francisco CA 94121	♀ **Where:**	37.784766 -122.50042
❷ **What:**	Museum	◑ **When:**	Morning
👁 **Look:**	Southwest	W **Wik:**	Legion_of_Honor_(museum)

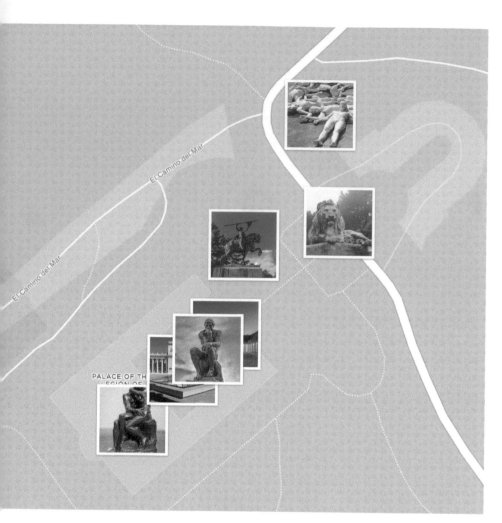

PALACE OF TH
LEGION OF

El Camino del Mar

El Camino del Mar

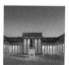

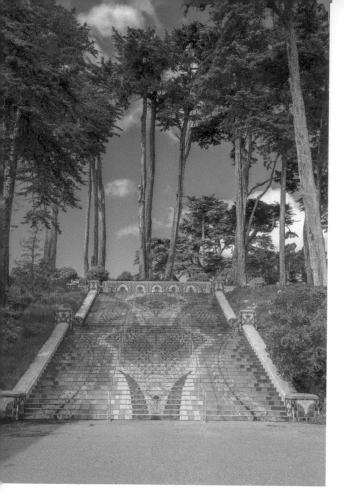

Lincoln Park Steps

Lincoln Park Steps is a tiled-mural-decorated historic entrance to Lincoln Park. Dating to the early 1900's, the grand staircase had fallen into disrepair by 2007, when Friends of Lincoln Park founders, Anna Yatroussis and Meg Autry, proposed a solution. Local artist Aileen Barr was hired to design and create the steps and after seven years, the drab walk became a magnificent beaux arts-inspired public art installation.

✉ **Addr:**	32nd Ave, San Francisco CA 94121	♥ **Where:**	37.7835385 -122.4933871
❓ **What:**	Steps	◑ **When:**	Morning
👁 **Look:**	West	↔ **Far:**	24 m (79 feet)

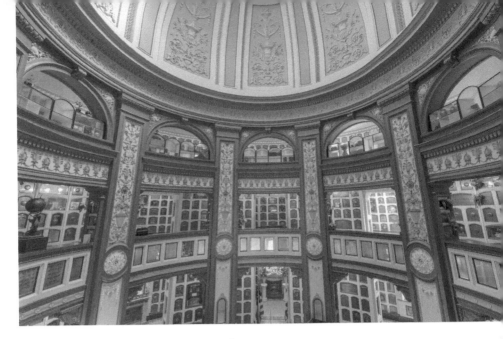

Neptune Society Columbarium is a copper-domed Neo-Classical resting place for cremated remains. Designed by British architect Bernard J. Cahill, the San Francisco Columbarium opened in 1898 with over five thousand niches.

The Columbarium was beautifully restored by the Neptune Society, owners since 1979.

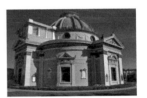

✉ **Addr:**	One Loraine Court, San Francisco CA 94118	♀ **Where:**	37.780597 -122.457067
❓ **What:**	Columbarium	◷ **When:**	Anytime
👁 **Look:**	North	W **Wik:**	Neptune_Society_Columbarium

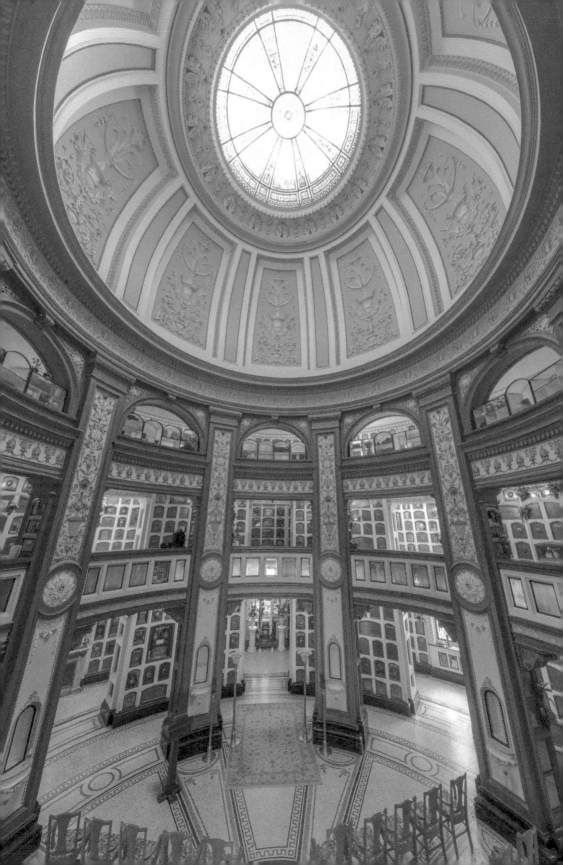

 Credits

Thank you to the many wonderful people and companies that made their work available to use in this guide.

Photo key: The number is the page number. The letters reference the position on the page, the distributor and the license. Key: a:CC-BY-SA; b:bottom; c:center; d:CC-BY-ND; e:CC-PD; f:Flickr; g:GNU Free Documentation License; h:Shutterstock standard license; j:Any use with attribution; s:Shutterstock; t:top; w:Wikipedia; y:CC-BY.

Cover image by Andrew Zarivny/Shutterstock. Back cover image by yunjun/Shutterstock. 53nt (53 sh); Aido (145 fy); Allie_caulfield (88t sh); Randy Andy (127 sh); Supakorn Angaumnuaysiri (71b sh); Anton_ivanov (69, 93t, 94t, 140 sh); Joseph M. Arseneau (158t sh); Caron Badkin (65t sh); Tono Balaguer (61 sh); Can Balcioglu (42, 129t, 106 wj); David Ball (16 fy); Shelby Bell (162 sh); Arne Beruldsen (80b fa); Jamie Beverly (23 fa); Matt Biddulph (23 fy); Billy7944 (35b sh); Blazg (78 sh); Bondrocketimages (163t sh); S Borisov (25, 51 sh); Canadastock (22t, 27t sh); Canyalcin (112t sh); Cdrin (123t, 160t sh); Checubus (89t sh); Zh Chen (105 sh); Ronnie Chua (46, 69t sh); Alessandro Colle (32t, 36 wy); Dale Cruse (104b wa); Caroline Culler (132 sh); Curtis (120 fy); David (97 sh); Alexander Davidovich (143 fy); Davitydave (112 sh); Songquan Deng (28 sh); Zhu Difeng (55 wa); Dllu (109 wa); Dreamyshade (124t sh); Epicstockmedia (17t sh); Eqroy (105 sh); F11photo (121t fy); Charles Fosterwhite Photography (21 sh); Prochasson Frederic (152t fy); Luke Fretwell (16b sh); Gagliardiimages (67t wa); Bernard Gagnon (155t fe); Gérard (157 sh); Alexandra Glen (61b sh); Haveseen (33 wa); King Of Hearts (97 sh); Eddie Hernandezy (150t fy); Tom Hilton (167 fy); Hitchster (37 sh); Gert Hochmuth (142 sh); Holbox (24t, 62 wa); Fred Hsu (68t fy); Jay Huang (57 sh); Imagezebra (156t fa); Dennis Jarvis (128t fy); Jeremy%20thompson (16 sh); Jessicakirsh (13t sh); Jhvephoto (159 wg); Jjron (152 sh); De Jongh (165b sh); Jts Photography (147 sh); Ruslan Kalnitsky (27b sh); Kenkistler (81b fy); Ketrin1407 (97 sh); Brian Kinney (62 sh); James Kirkikis (67b, 74t, 113, 138t sh); Irina Kosareva (85t sh); Kropic1 (43 sh); Ingus Kruklitis (47t sh); Radoslaw Lecyk (41b, 58t sh); Pius Lee (48t, 50t, 62t sh); Rafael Ramirez Lee (52, 132t sh); Dylan Lem (43b sh); Co Leong (83 sh); Kit Leong (101t sh); Llullavi (166t sh); Lorcel (41t sh); Luciano Mortula - Lgm (153 sh); Lucky-photographer (52 sh); Lucvi (52t sh); Martin M303 (17b wa); Joe Mabel (84t sh); Benny Marty (59t fy); Jamie Mccaffrey (131t fy); Mk97007 (75t fa); Mliu92 (114 sh); Luciano Mortula (19, 27, 40, 144t sh); Nagel Photography (21 fy); Karen Neoh (105b sh); Nito (137 sh); Sergey Novikov (77t sh); Oomka (119b sh); Oscity (64, 81t wa); Ossobuco (159t sh); Papuchalka (44t sh); Sean Pavone (148 sh); Bill Perry (138 sh); Somchai Phongraknanon (68b sh); Iris Photoimages (92b wa); Pimpinellus (150 sh); Pixelshop (111 sh); Eug Png (130t sh); Ekaterina Pokrovsky (28t, 104t sh); Pung (21b, 110t fy); David Pursehouse (133t sh); Peeradach R (118 fy); Ben Ramirez (94b sh); Mic Rees (72b sh); Luz Rosa (50b, 160 sh); Roschetzky Photography (72t sh); Marco Rubino (30t fy); Sarah (84 sh); Tinnaporn Sathapornnanont (135t, 149 sh); R Scapinello (61 fa); Scott Schiller (123 sh); Dan Schreiber (156 sh); Mark Schwettmann (28 sh); Iuliia Serova (55t fy); Arun Shivaram (98t fy); Vince Smith (136t sh); Solarisys (69 fy); Solyanka (142 fy); Marvin Soriano (43 fd); Spiros%20vathis (126t sh); Nickolay Stanev (120t, 121, 151t sh); Studioeau (22b sh); Sundry Photography (114t sh); Svetlanasf (165t fy); Switthoft (125t sh); Phitha Tanpairoj (43t sh); Tarapatta (88b sh); Pal Teravagimov (38t sh); Travelview (14, 76 sh); Tsuguliev (73 sh); Tupungato (87t sh); Michael Urmann (47b, 95t, 102, 116t sh); Vacclav (80t fd); Spiros Vathis (142t sh); Ventdusud (48b wa); Charlie Vinz (115 sh); Lebid Volodymyr (18t, 99t sh); Martin D. Vonka (31, 126 fa); Pascal Vuylsteker (148t sh); B.a. Wallace (82 sh); Michael Warwick (37t, 154t fy); Marcin Wichary (35t sh); Willowtreehouse (87b fy); Travis Wise (107t wa); Wolfmansf (82t sh); Steve Wood (137t sh);

Framed World (130 wa); Xaven (161t sh); Lynn Yeh (92t, 119t, 139t sh); Yhelfman (71t, 108, 122t, 129, 167t sh); Yunjun (109t sh); Andrew Zarivny (100t, 106t, 127t, 134 sh); Leonard Zhukovsky (90, 97 sh).

Some text adapted from Wikipedia and its contributors, used and modified under Creative Commons Attribution-ShareAlike (CC-BY-SA) license. Map data from OpenStreetMap and its contributors, used under the Open Data Commons Open Database License (ODbL).

This book would not exist without the love and contribution of my wonderful wife, Jennie. Thank you for all your ideas, support and sacrifice to make this a reality. Hello to our terrific kids, Redford and Roxy.

Thanks to the many people who have helped PhotoSecrets along the way, including: Bob Krist, who answered a cold call and wrote the perfect foreword before, with his wife Peggy, becoming good friends; Barry Kohn, my tax accountant; SM Jang and Jay Koo at Doosan, my first printer; Greg Lee at Imago, printer of my coffe-table books; contributors to PHP, WordPress and Stack Exchange; mentors at SCORE San Diego; Janara Bahramzi at USE Credit Union; family and friends in Redditch, Cornwall, Oxford, Bristol, Coventry, Manchester, London, Philadelphia and San Diego.

Thanks to everyone at distributor National Book Network (NBN) for always being enthusiastic, encouraging and professional, including: Jed Lyons, Jason Brockwell, Kalen Landow (marketing guru), Spencer Gale (sales king), Vicki Funk, Karen Mattscheck, Kathy Stine, Mary Lou Black, Omuni Barnes, Ed Lyons, Sheila Burnett, Max Phelps and Les Petriw. A special remembrance thanks to Miriam Bass who took the time to visit and sign me to NBN mainly on belief.

The biggest credit goes to you, the reader. Thank you for (hopefully) buying this book and allowing me to do this fun work. I hope you take lots of great photos!

© Copyright

> *"'And what is the use of a book,' thought Alice*
> *'without pictures or conversations?'"*
> *— Alice's Adventures in Wonderland, Lewis Carroll*

© Copyright

⚓ Disclaimer

The information provided within this book is for general informational purposes only. Some information may be inadvertently incorrect, or may be incorrect in the source material, or may have changed since publication, this includes GPS coordinates, addresses, descriptions and photo credits. Use with caution. Do not photograph from roads or other dangerous places or when trespassing, even if GPS coordinates and/or maps indicate so; beware of moving vehicles; obey laws. There are no representations about the completeness or accuracy of any information contained herein. Any use of this book is at your own risk. Enjoy!

✉ Contact

For corrections, please send an email to andrew@photosecrets.com. Instagram: photosecretsguides; Web: www.photosecrets.com

■■ Index

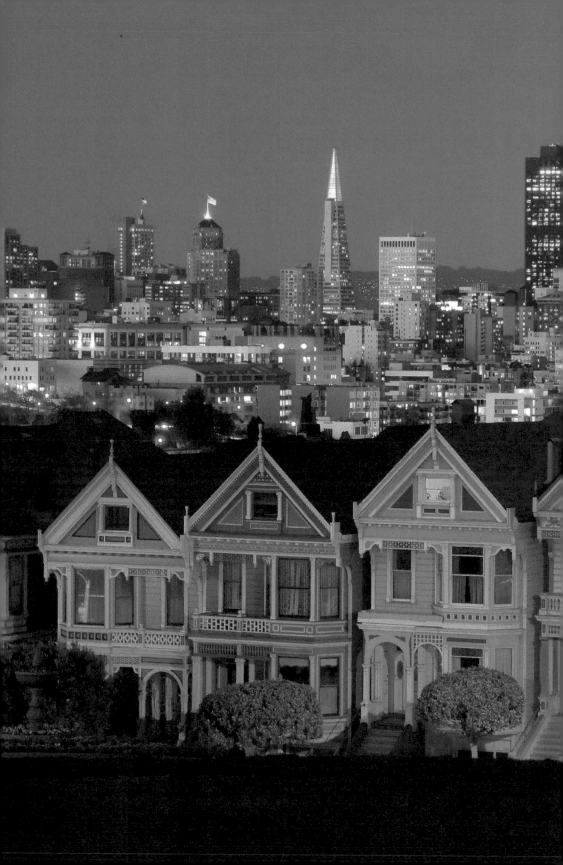

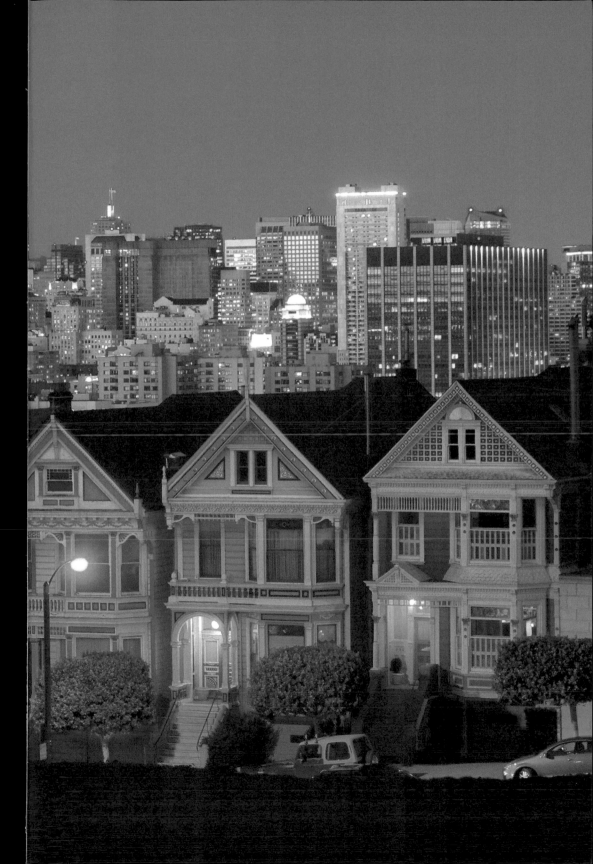

◀ Welcome

By Andrew Hudson

THANK YOU for reading PhotoSecrets. I like to start books by flicking from the back cover, so this is a good place for a welcome message.

As a fellow fan of travelling with a camera, I hope this guide will quickly get you to the best spots so you can take postcard-perfect pictures.

PhotoSecrets shows you all the best sights. Look through, see the classic shots, and use them as a departure point for your own creations. Get ideas for composition and interesting viewpoints. See what piques your interest. Know what to shoot, why it's interesting, where to stand, when to go, and how to get great photos.

Now you can spend less time researching and more time photographing.

The idea for PhotoSecrets came during a trip to Thailand, when I tried to find the exotic beach used in the James Bond movie *The Man with the Golden Gun*. None of the guidebooks I had showed the beach, so I thought a guidebook of postcard photos would be useful. Twenty-plus years later, you have this guide, and I hope you find it useful.

Take lots of photos!

Andrew Hudson

Andrew Hudson started PhotoSecrets in 1995 and has published 20 nationally-distributed color photography books. His first book won the Benjamin Franklin Award for Best First Book and his second won the Grand Prize in the National Self-Published Book Awards.

Andrew has photographed assignments for *Macy's*, *Men's Health* and *Seventeen*, and was a location scout for *Nikon*. His photos and articles have appeared in *National Geographic Traveler*, *Alaska Airlines*, *Shutterbug*, *Where Magazine*, and *Woman's World*.

Born in England, Andrew has a degree in Computer Engineering from the University of Manchester and was previously a telecom and videoconferencing engineer. Andrew and his wife Jennie live with their two kids and two chocolate Labs in San Diego, California.